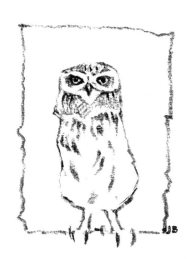

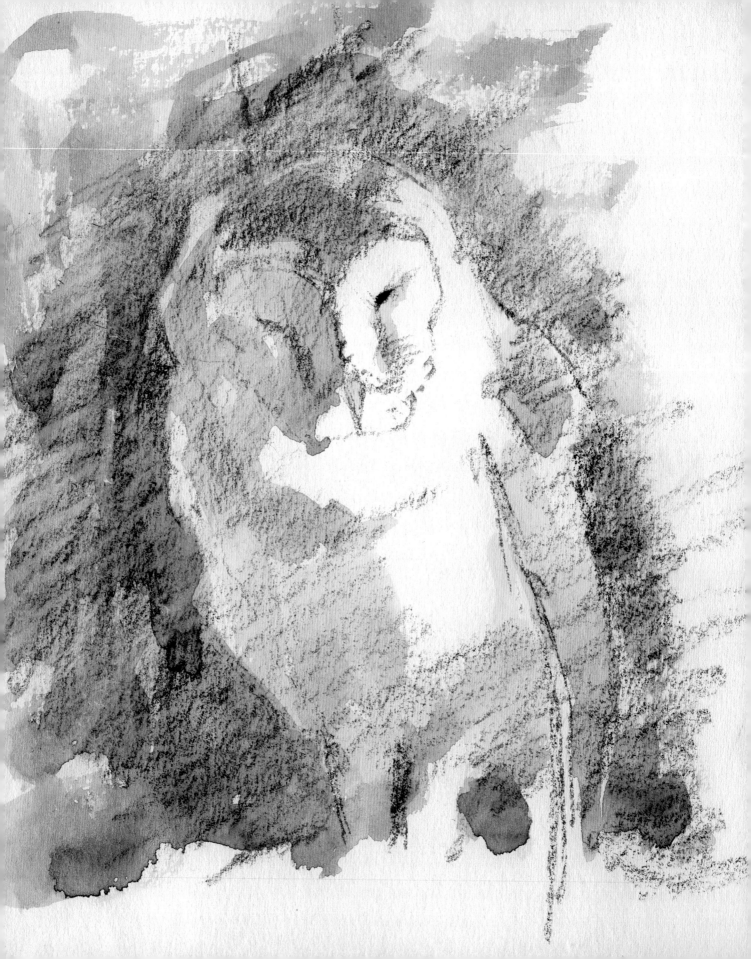

Drawing Birds

John Busby

SECOND EDITION

TIMBER PRESS · PORTLAND, OREGON

Acknowledgements

My thanks go first of all to the artists who have made this book possible and who generously supplied enough drawings and paintings for a book three times the size. Such is the enthusiasm of artists who draw their inspiration from living birds.

A special thank you to Barry Van Dusen, who carries a similar flag in the USA, for good advice and contacts with American artists.

My thanks also to those who lent paintings from their collections: to Hugh Ennion and Chloe Talbot Kelly for their respective father's work; to Bob Walthew who lent several Ennion drawings; to Robert Gillmor for the page of a Japanese copy book from A.W. Seaby's collection; to Andrew Haslen of The Wildlife Gallery, Lavenham; to the late Nigel Ede of Arlequin Press, and the Trustees of the Tunnicliffe Estate.

For permission to reproduce I thank the Ashmolean Museum, Oxford, for Ruskin's *Kingfisher*, the Burrell Collection, Glasgow for Joseph Crawhall's *The Pigeon*, the Robert Foundation, Beil, Switzerland for (Leo)-Paul Robert's paintings, and The Bodley Head for the page from J. A. Shepherd's Bodley Head Natural History. The Bridgeman Art Library staff have been most helpful in finding images needed in chapter one. I thank 'Common Ground' for permission to quote again from David Measure's article in *Second Nature* and St Andrews Press and Kenneth Steven for the verse from 'Wild Horses'.

A big thank you to the RSPB and Mark Boyd in particular for their act of faith in agreeing to a new version of *Drawing Birds*, first published 16 years ago, to Sylvia Sullivan for again taking on the task of editing the text and to Mike Unwin of A & C Black for his help. Also to Bob Walthew again, for compiling a very thorough bibliography to round off the book, and especially to Nye Hughes of Dalrymple, Edinburgh, himself a keen naturalist and artist, who has brought the book together with a superb layout.

Finally to my wife Joan for rescuing me time after time from computer tangles and keeping ruffled feathers in place.

JOHN BUSBY, ORMISTON, DECEMBER 2003

Published in the USA in 2005 by Timber Press, Inc.
The Haseltine Building, 113 sw Second Avenue,
Suite 450, Portland, Oregon 97204-3527

www.timberpress.com

ISBN 0–88192–697–3

A catalog record for this book is available from the Library of Congress

Designed and typeset by Dalrymple, Edinburgh
Printed and bound in Hong Kong

10 9 8 7 6 5 4 3 2 1

Illustrations by John Busby:

Front cover: *Fieldfare*
Half tile: *Little Owl*
Frontispiece: *Barn Owl*
Opposite: *Choughs*
Back cover: *Common Cranes*

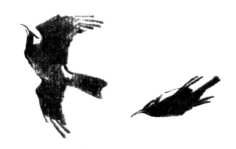

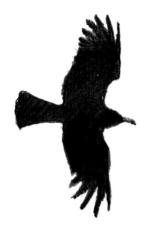

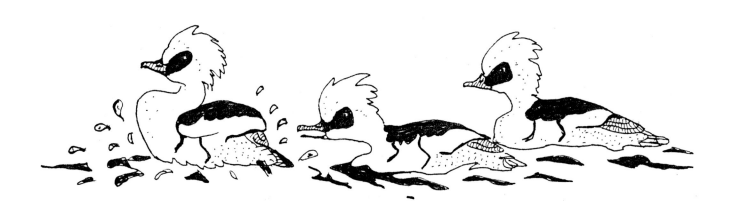

Foreword

Have you ever been to the annual Bird Fair at Rutland Water? If not, you should. I guarantee that you will be overwhelmed by the vast range of exhibits, events, film shows and so on. I'll also lay a small bet that one of your favourite places will be the Art Tent – actually an enormous marquee. Inside you will be able to see the work of most of Britain's top bird artists and illustrators. You can also meet the artists themselves, and – perhaps most intriguingly – watch them at work.

Two things may strike you. Firstly, that nearly every artist has his or her own distinctive style. A bird species may not vary much in nature, but its image surely will on the page or canvas. Some will be almost photographically accurate; others abstract or impressionistic. Some will feature the surroundings as much as the bird; others will have no background at all. The fact is, give a group of artists the same bird to draw or paint and no two versions will look the same. So, point one: present day bird art is incredibly varied. Point two: it is almost all impressively good! But don't be intimidated. Be inspired.

There are many reasons why you should have a go yourself. Firstly, a field sketch (no matter how primitive) is worth a page of notes when trying to identify an unfamiliar bird, or prove you really have seen a rarity. Even if your effort resembles a cross between a couple of eggs and one of those meat cut charts you see in a butcher's, it is still better than nothing. I know birders who predraw basic 'identishapes' in their notebooks, and mark in the colours while observing the real thing!

And that brings me to one of the chief challenges and benefits of drawing birds. To draw them, you have to look at them. Really look at them. Not just the patterns and markings, but also the distinctive shapes and postures. And as you look, you are bound also to appreciate what the bird is doing. How it moves, flies, feeds, sleeps, displays and so on. Scientists call it 'studying behaviour'. I call it bird watching!

Above all else though, is enjoyment: both the satisfaction of seeing your work improve, and the sheer physical pleasure of sketching or painting.

One thing is for sure: you couldn't have a better mentor than John Busby. Mind you, don't be fooled by the apparent simplicity of his style. It may look 'easy' but it most certainly isn't. As some astute jazz musician once said; 'less is more', and that certainly applies to John's approach to drawing. But it doesn't have to be that way. The trick – to quote possibly the same musician – is to 'do your own thing'.

So, go on, get that pencil out and have a go. Remember: however it turns out, nobody need see your efforts except yourself. On the other hand, maybe next year it'll be *your* portfolio I'll be admiring in the Art Tent!

Good luck, and enjoy.

BILL ODDIE

◄
Bill Oddie
Smew
Ink pen

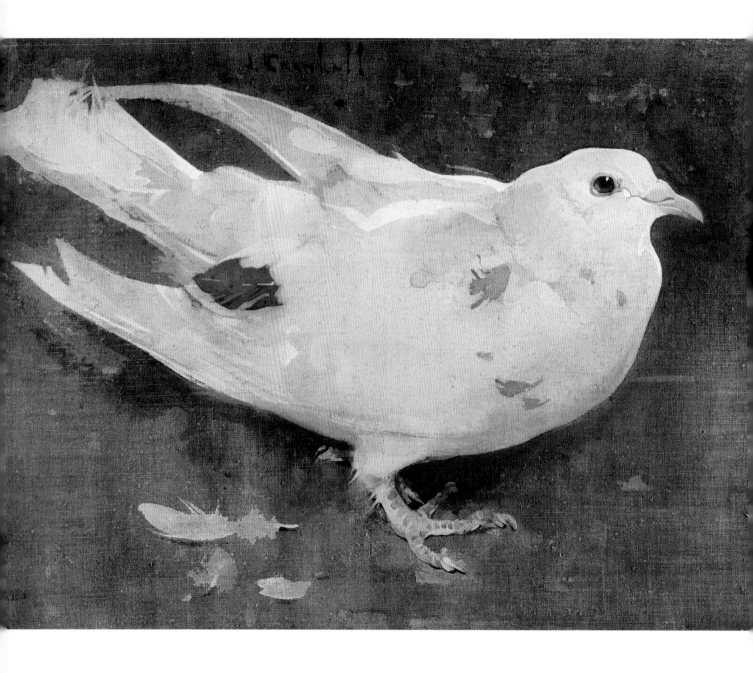

1 Birds on the Brain

Throughout the ages, whenever artists have made images from nature, birds have caught the imagination and inspired a creative response. They are seen as both beautiful and sinister, glorious in plumage but hard of eye and wild of spirit; as a quarry to be hunted for food and as inhabitants of the world of air, symbols of freedom beyond human reach. They have been made into the likenesses of gods and fashioned into heraldic and national emblems of power. Even the invisible forces of good and evil have been given form as white dove and night-backed raven. In themselves, birds are beautiful in form and movement, and so superbly decorative that they appear as motifs on all manner of ornament from pottery to postage stamps, tapestry to tableware, all over the world.

Plumage pattern is one of the richest veins in all nature, variety beyond anything artists can imagine for themselves. However, plumage detail in a painting rings true in art only when it is one with the vitality of the whole bird.

Bird painting was part of the culture of early China and Japan. According to Hseih Ho, the 6th-century Chinese master, vitality was the first and highest of the six principles of painting.[1] To the artists of the Far East, painting was an act of celebration as well as decoration. Peacock, pigeon, finch and crane are painted with a rhythmic grace and energy to match their character and keep them in harmony with their surroundings.

In the west, nature painting emerged only

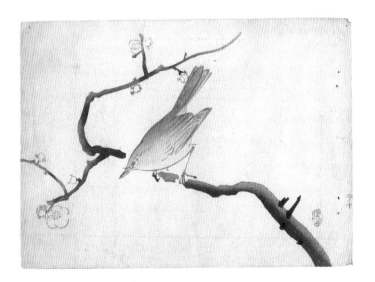

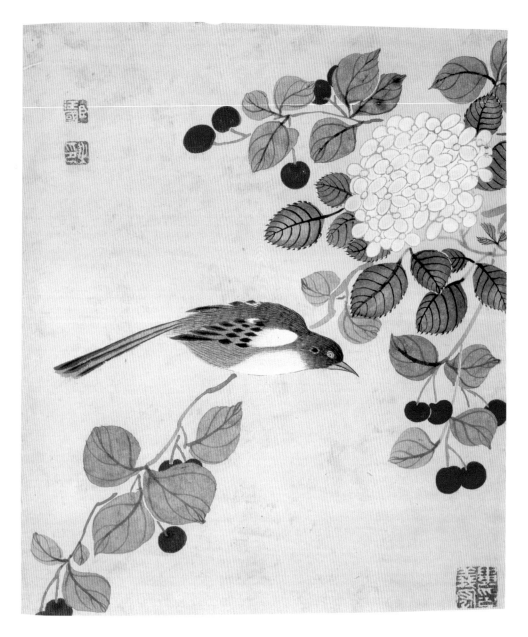

slowly as background detail to great religious and secular themes. Artists for the most part found wild birds too elusive to 'capture' in paint and, unless they confined themselves to tame species or made imaginative guesses about those they saw only fleetingly, the only recourse for many was to paint from dead birds. This practice led to rather static poses where a bird was painted as part of the quest for knowledge of species classification. The early scientist-artists who illustrated their own studies made accurate rather than freely artistic paintings of birds. Often with great artistry, but sometimes with little knowledge of the living bird, they recorded details of a bird's plumage. Although the

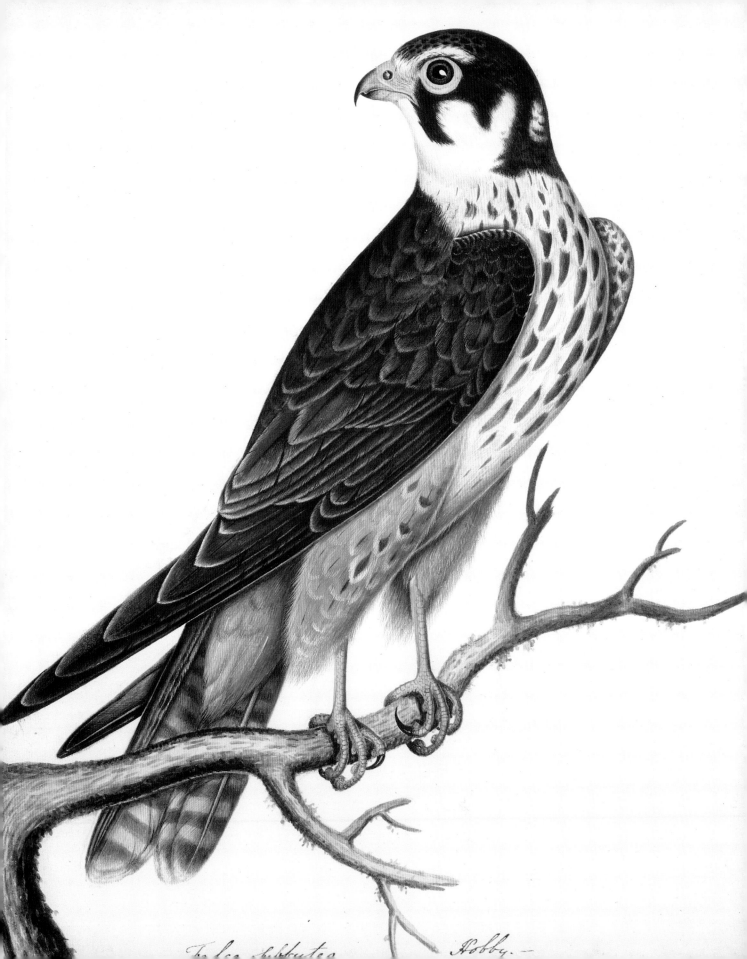

Falco subbuteo Hobby.—

paintings are often naive or quaint, and owe most to a museum specimen, the etching process and subsequent hand-colouring gave these early book plates an attractive clarity lost in many modern illustrations.

Today, with the aid of binoculars and telescopes, we can see wild birds with an intimacy undreamed of in the past, and we can watch behaviour that is unaffected by the fear of close human presence. This has opened up tremendous pictorial possibilities, and our understanding of behaviour has been enhanced by ornithological research. Yet, for some artists the 'definitive study' seems to dominate all other concepts of bird portraiture, to such an extent that an artist can be trapped creatively by the sheer weight of known facts by which he or she thinks the 'rightness' of a picture will be judged.

Correctness can become an obsession, and in some pictures one can imagine the artist ticking off a checklist of detail to be included before a bird can be considered finished. This is a formidable inhibition; one that can make a beginner doubt his or her own observation and suppress original creative ideas.

Artists also have a tendency to idealise nature and pander to patrons who like nature-art to represent perfection, just as flattery is often preferred in human portraits. However, birds in less than their full spring plumage are just as interesting as the immaculate specimen.

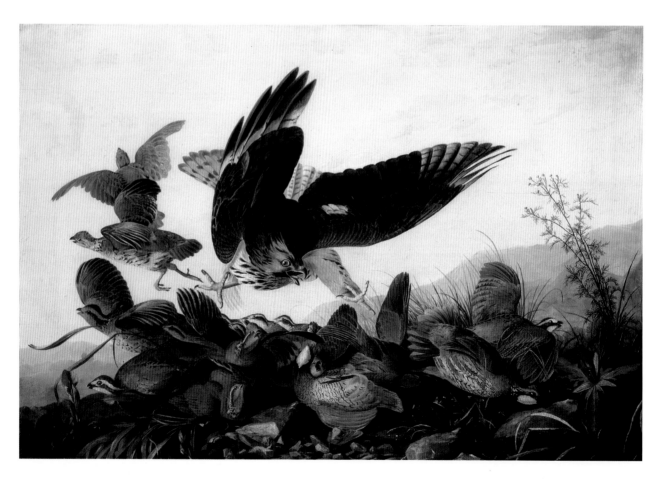

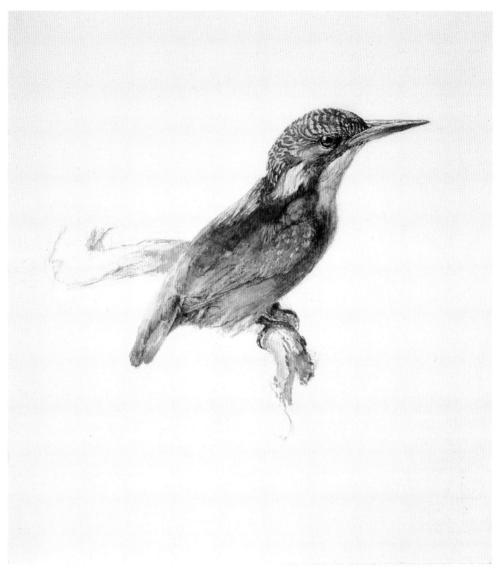

▸

John Ruskin, 1819–1900
*Study of a Kingfisher, with
dominant reference to colour,
1870 or 1871*
watercolour

*One of many studies from
nature used by Ruskin to
illustrate his lectures. It is a
meticulous study with paint
applied mostly in small
brush strokes in the manner
of later Pointillists.*

 *Ruskin wrote, 'If you have
a good eye for colours, you
will soon find out how
constantly Nature puts
purple and green together,
purple and scarlet, green and
blue, yellow and neutral grey,
and the like and how she
strikes these colour-concords
for general tones, and then
works them with innumer-
able subordinate ones, and
you will gradually come to
like what she does, and find
out new and beautiful chords
of colour in her work every
day'.[7] Ruskin was a strong
advocate of a 'back to nature'
movement in art, and his
lectures and writings
influenced many artists. They
are well worth reading today.*

A painting of a summer loon on a sky-blue lake may sell better than a painting of a great-northern diver in the grey seas of winter. The first has become a conventional cliché, the other might grow from an unforgettable moment seen. Work that springs from first-hand, vital experience, could be more difficult to sell but would be far more rewarding to live with.

Nature in art should be truthful. 'Be guided by life within nature, for only out of this can truth be created', wrote Dürer in his 16th-century treatise on proportion.[2] But is wildlife art more truthful if it is entirely objective, free from all expression of feelings? Some think so. There are two kinds of truth to consider: one made up of facts we measure and record; the other revealed by how we interpret our experience of reality. There is a creative objectivity that can show itself in other ways. In the 19th century, John Ruskin called for a 'Return to Nature' as a

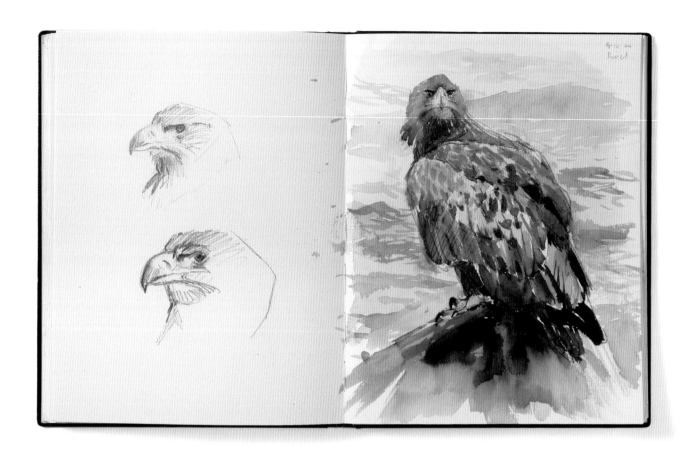

break with artistic conventions and the academic art of his day. Many revolutions in art began like this, turning a fresh, more truthful eye on the world. Audubon in America changed the way artists looked at nature. Even though he worked from dead birds, Audubon broke the mould of ornithological illustration and gave his birds a passionate intensity that is striking even today. His attention to detail was objective enough, but the resulting energy and individuality of his work are anything but.

In Sweden, Liljefors, though less revolutionary in style, brought a new objectivity to the portrayal of nature. He painted what he saw, devoting himself to a lifetime watching birds and animals in the wild – not posing, but being themselves. There is a breathless sense of 'being there' about his work. He handled paint with a mastery that Rubens would have admired, responding brilliantly to textures (the fur of a fox), to movement (a hawk in action), and to infinitely subtle qualities of light and times of day, with all the instinct of a great conductor for the balance of every orchestral detail. However objective in intention, his work is a powerful, optimistic testimony to man's relationship with nature – a deep-felt love without trace of sentimentality.

Today, Lars Jonsson, also a Swedish artist, takes this quality of a creative 'back-to-nature' into the age of the telescope. No artist before him has combined such knowl-

edge of birds with such skill in painting them. They exist in the light-filled air that surrounds them, seen with a poet's eye for what is truly important. His paintings celebrate the joy of moments shared with living birds.

There are many artists now in Europe and America who work directly from living birds. This in itself is a revolution from the popular genre of wildlife art based mainly on photographs and second-hand experience. To render great detail in works of art can be exciting and often very skilful, giving a heightened sense of reality. Paintings by such artists as George Maclean of Canada show how it can be done, but it needs great subtlety of composition if the artist is not to saturate a picture with visual facts, giving an effect so contrary to the way anything in

nature is perceived that the much sought-after authenticity is lost. It sometimes seems as if an artist is in competition with nature and with photography at the same time, trying to go one better and ending with a false, uncomprehending realism.

Photography, by contrast, has revolution-ised our view of nature, often outdoing artists creatively. Long lenses and high-speed cameras reveal more than the eye can normally see, and artists should find this a challenge, not to copy photography, but to see more themselves and break free of old habits of seeing. Artists who work in the field can learn much from the patience and dedication of wildlife film-makers.

In response to the demand for identification guides to the world's birds, field guides have replaced the old scientific books. They

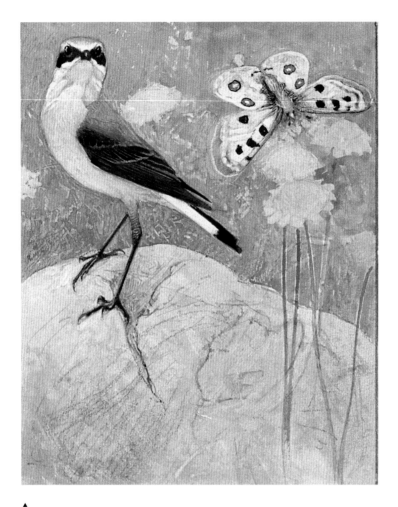

▲

(Léo)-Paul Robert, 1851–1923
Traquet Motteux
(Northern Wheatear in spring
plumage, with Apollo butterfly)
watercolour

The bird paintings of (Léo)-Paul Robert deserve to be far better known outside Switzerland. They were remarkable when painted by a young man with a passion for nature and great skill as a painter, and they are as fresh and relevant today. Léo-Paul captured the character of his birds beautifully, and he places them with equal accuracy, in typical habitat. His love of nature – birds, butterflies and plants – developed at an early age, and he grew up as part of a profes-

sional artistic family. His father, Aurele, was famous as a painter of peasant life, with ateliers (studios) in Italy. Léo-Paul enjoyed success illustrating the birds of Switzerland and he was later also a figurative painter of renown, famous especially for large allegorical works including two public murals and a mosaic in Bern Town Hall. In 1903, disillusioned by modern trends in art, he turned from grand-scale works to devote himself to painting caterpillars, bringing to these neglected creatures all his skill as a painter. He wanted people to see the wonder of the humblest of God's creation. Like the birds, these were painted from life in their natural settings.

are a ready reference for the diagnostic features of birds, invaluable in teaching identification skills. When I was a boy no such books existed, so learning the look of unfamiliar birds had to be gleaned from direct experience, perhaps with the help of a friendly expert. Modern field guides follow the simple and practical example set in the 1950s by Roger Tory Peterson, presenting similar species side by side in stylised side view. Colour is shown with a laboratory sharpness, while habitat, which in life always affects a bird's appearance, is usually ignored. By their nature field guides present a stereotype of an average bird, which in reality does not exist. They also reinforce the idea that the sole purpose of watching birds is to identify them.

Some guides go beyond the stiff side-view image and manage to show the character of a bird through its posture. J. A. Shepherd did this most tellingly with line only in the Bodley Head Natural History volumes in 1913,[3] and more recently the field guides of Lars Jonsson[4] show how much the 'jizz' of a bird aids its identification. They also show that artistic discernment in the handling of detail helps one to see. Photographic and digitally enhanced guides may attempt to go one better, but the artist always has the ability to select what is important and use the negative spaces of a designed page to full advantage.

Many people's mental images of birds come from book illustrations and paintings, and naturally painters and illustrators have been the main innovators of bird art. One thinks of the Renaissance masters, Pisanello and Carpaccio, and the flight studies of Leonardo; the Dutch painters of domestic and menagerie birds; Liljefors and his influence on Scandinavian artists; Thorburn

Pablo Picasso, 1881–1973
The Dove, 1949
gouache on paper

Picasso's name is synonymous with the avant-garde art of the first half of the 20th century. For all his powerful abstractions of people and the shock of his many innovations, he was capable of expressing great tenderness. Dove motifs occur quite frequently, taking on their symbolic role representing peace. This one, surrounded by intense black, seems as vulnerable as peace itself.

▼

and Lodge, his exact contemporaries in Britain; Peter Scott and Charles Tunnicliffe; Joseph Wolf in Germany; the Robert family in Switzerland; Fuertes and Abbot and Gerald Thayer in America, forerunners of new generations of wildlife artists.

Though he is less well known, a painter I hold in great esteem is Joseph Crawhall, who was associated with the 'Glasgow School' at the turn of the 20th century. Crawhall's work combines superb draughtsmanship and composition with strong feeling for the inner life of his subjects. His birds are

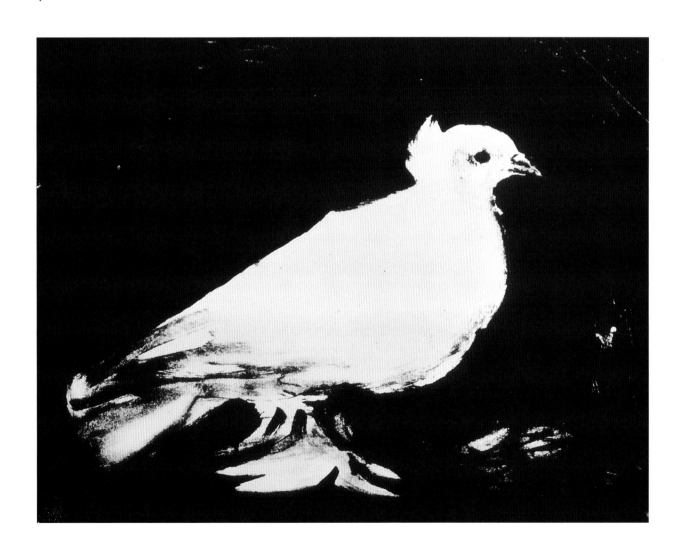

mainly domestic; cocks, ducks and tame jackdaws. His gouache painting *The Pigeon*, now in the Burrell Collection in Glasgow, is a masterpiece. You feel the life of the bird looking out at you through its eyes. Winslow Homer, who met the young Crawhall when he visited England, also painted some fine birds. However, birds appear only rarely as themes of modern artists. Picasso's lithographs of owls and doves are beautifully drawn, strongly evocative and overlaid with symbolic meaning. The painter Braque and sculptor Brancusi used bird motifs all their lives – highly personal symbols that refined the spirit of birds and flight. Light-hearted birds can be found in the paintings of American artist Milton Avery, and strong birds in the drawings and sculpture of Elizabeth Frink.

Openness to the wider world of art is as essential to growth in pictorial imagination, as the experience of living birds is vital to understanding your subject matter. The choice facing those who aspire to draw and paint birds today is whether to fall back on past images, and to copy accepted styles of conventional, often market-driven wildlife art, or to go direct to nature and respond to living birds. My choice was made long ago when in my early teens an enlightened great aunt gave me a copy of R. B. Talbot Kelly's *The Way of Birds*.[5] This artist and Eric Ennion, whom I met while a student at Edinburgh, opened a window into a new passionate reality after the stuffy plates of my earlier bird books and confirmed my choice to go live.

Too many wildlife artists shut their eyes to the wider world of art, and then complain that their own work, which may ignore the aesthetic and emotional energies that are the lifeblood of art, is not admitted into the

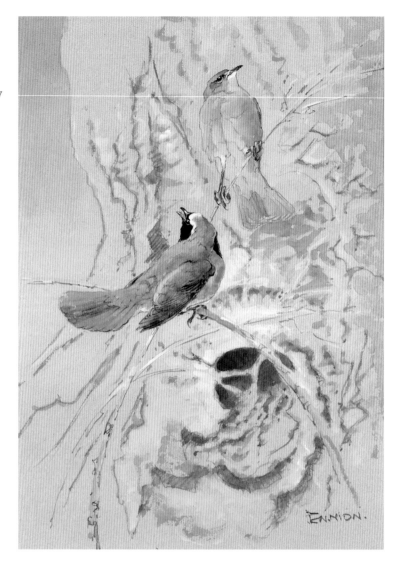

▲

Eric Ennion
A pair of Redstarts
watercolour on tinted paper
heightened with white

Eric painted the birds with an intimacy gained not just from observation, but from holding many birds in his hands as a ringer and feeling their heartbeats. The underlying structure here is an S shape. The arcs of branches contrast with the curves in the bird's bodies – one bird facing into the space, the other out.

▶

R. B. Talbot Kelly, 1896–1971
Pochard on ice
watercolour

A drake Pochard trying to push itself over an ice-covered lake drawn with great mastery of economical line after a moment seen and vividly remembered. Talbot Kelly's unique way of seeing and his book The Way of Birds[5], *published in 1937, came like a breath of fresh air into British wildlife painting.*

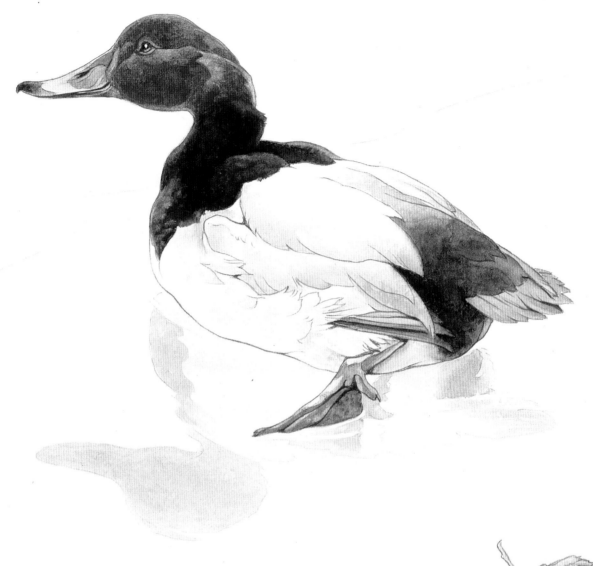

then I saw the two owls
in the tree I did not Like it
When the owls twisted it's head
aound The owls were big. I heard
it makeing a nose.
Love Malka silis

▼
Anna Leslie
Crane
ballpoint pen

*Drawn by Clare Walker
Leslie's daughter when
she was aged 8.*

▲
Malka Sills
Two owls in a tree
ballpoint pen

*Drawn from memory
after seeing the owl
from her bedroom
window aged 6.*

same league. Knowledge of subject matter alone is not enough. Art is a synthesis; a unity of ideas and the means to express them. In a painting there has to be a pictorial reason for the relationships that are made between shapes and spaces, lights and darks, colours, rhythms of line – everything that controls the movement of the eye as the painting is read. These forces only come together in a work of art. They do not exist in nature in a relationship under human control. In a picture they are governed by the artist's choice. One cannot draw or paint 'what one sees' in front of one without being aware of what is happening on the page or canvas in the process. However fascinating the subject matter, we need an equal fascination with the whole business of making marks with which, in a child-like way, we can identify. To copy nature without resolving our own thoughts and feelings is a barren experience.

In much truly ethnic art made by people who live in everyday contact with nature, we find images that express the 'spirit' of the bird rather than describe physical attributes – sculptures and paintings which bring to life the beauty of the whole creature and what that means to the artist. Similarly, in the work of children there is often a directness that has an emotional charge, heightened rather than impeded by lack of sophisticated technique.

Drawing Birds is mainly about drawing – the most immediate and fundamental language of artists in any medium, a language of ideas. However, it expands into painting, colour and composition. Throughout I have used examples by artists who work from life, showing many drawings made on the spot, often with no particular end product in mind. They clearly reveal the

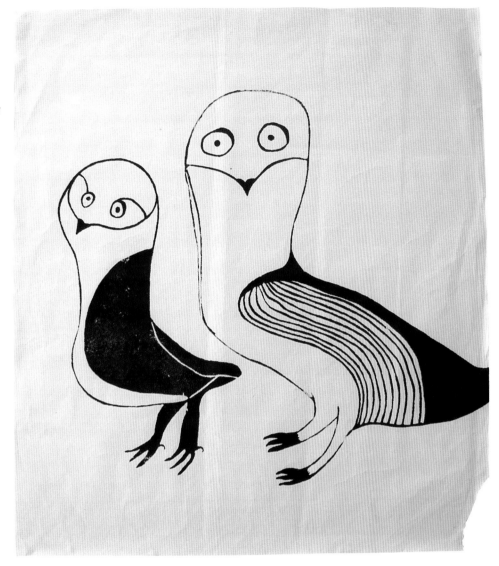

working thoughts of the artists. Some of the artists have been practising for years, others are just starting. I hope our vision of birds reflects the freshness and the excitement of our experiences, and that we have been able to pass on enough helpful practical advice to encourage those who also draw from nature.

Even without aspirations to draw, I am sure you will find here fresh ways of looking at birds, and new insights into their meaning in art.

1. *p.168,* An Approach to Botanical Painting, *Ann-Marie & Doun Evans, Hemmingford and Evans, Rutland 1993.*
2. *Translated from* Treatise on Proportion, *Albrecht Dürer, 1528.*
3. Bodley Head Natural History, *J. A. Shepherd, The Bodley Head, 1913.*
4. *For example,* Penguin Nature Guides, *Lars Jonsson, Penguin Books 1978–79 and* Birds of Europe, *Lars Jonsson, Christopher Helm, 1992.*
5. The Way of Birds, *R. B. Talbot Kelly, Collins, 1937.*
6. The Birds of America, *John James Audubon, Havell, London, 1831–1834.*
7. Elements of Drawing – on colour and composition, *John Ruskin, 1857, illustrated edition by Bernard Dunston, Herbert Press 1991, reprinted 1997.*

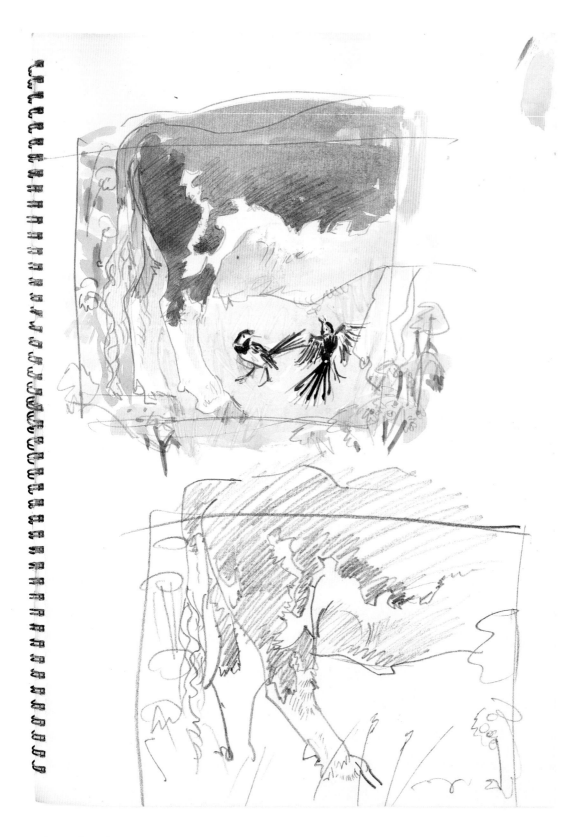

▶

David Koster

Wagtails under a cow
pencil and watercolour

Birds like Starlings and
wagtails often follow cattle
to pick up insects disturbed
by the animals. This light-
hearted sketch is a possible
motif for one of David
Koster's lithographs.

▶

Jennie Hale

Bullfinch in the hedge
sketchbook study, pencil and
watercolour

Jennie Hale is well known for
her Raku sculptures of
mammals and birds. She
uses her sketches to inform
her pottery and she retains a
childlike sense of delight and
fun in both.

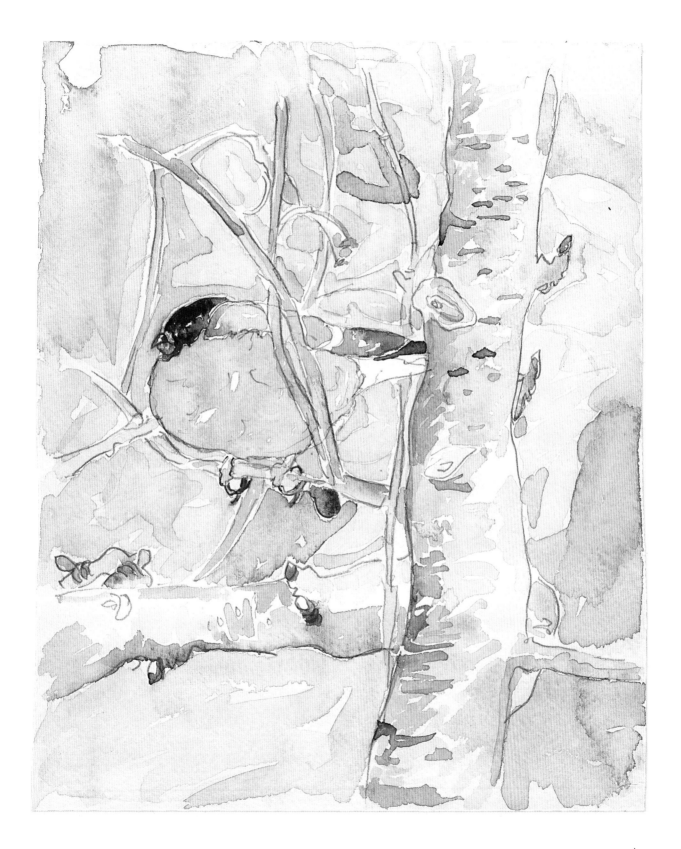

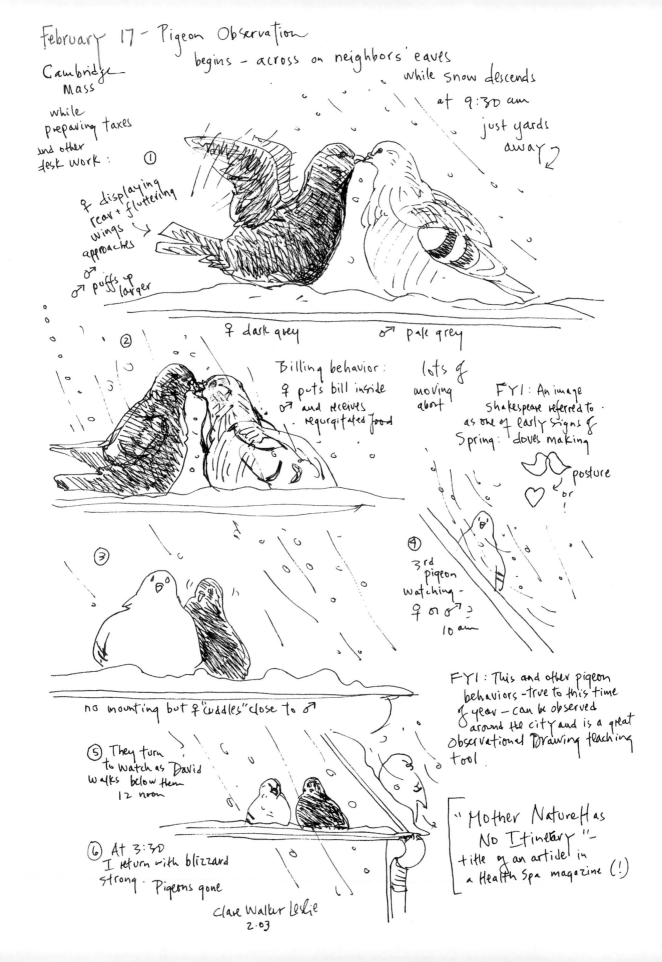

February 17 — Pigeon Observation

Cambridge Mass

begins - across on neighbors' eaves

while snow descends
at 9:30 am
just yards
away

while preparing taxes
and other
desk work :

① ♀ displaying
rear + fluttering
wings
approaches
♂ puffs up
larger

♀ dark grey ♂ pale grey

② Billing behavior:
♀ puts bill inside
♂ and receives
· regurgitated food

lots of
moving
about

FYI: An image
shakespeare referred to
as one of early signs of
Spring: doves making
posture
♡ or

③

④ 3rd
pigeon
watching -
♀ or ♂ ?
10 am

no mounting but ♀ "cuddles" close to ♂

FYI: This and other pigeon
behaviors - true to this time
of year - can be observed
around the city and is a great
Observational Drawing teaching
tool.

⑤ They turn
to watch as David
walks below them
12 noon

⑥ At 3:30
I return with blizzard
strong. Pigeons gone

"Mother Nature Has
No Itinerary" -
title of an article in
a Health Spa magazine (!)

Clare Walker Leslie
2·03

2 Birds in the Eye

Clare Walker Leslie
Pigeons in a snow storm
ink drawing

This is a typical nature diary page by this well-known American artist, author and enthusiastic educator, who has done much in the United States to encourage people interested in nature to look and draw, whether they think of themselves as artists or not. Written notes with a drawing engage both sides of the brain at the same time, so I am told!

▼

John Busby
Shore birds
pencil

Birds and posts: a kind of visual algebra where the spaces are part of the equation that sets the scene.

It is tempting to think that drawing can be taught methodically to a set of rules. Over the years of teaching at an art college I know that despite my advice and stage-managed exercises, the students have largely taught themselves through much practice and experiment once the basic skill of rendering a solid object on a flat piece of paper has been achieved. It is a process of learning gradually by trial and error to see – not merely to copy, but to see in a way that makes creative drawing possible. In this way you will begin to find the lines and marks that make sense of the subject, and be able to interpret its proportions, structure and rhythms, and its relationship to other things including yourself. Drawing taught to rigid rules seldom produces anything with real vision behind it. So much depends on a gut feeling for what matters. There are no rules governing the emphasis an artist may choose to put on something, or on what to leave unsaid. The 'tone of voice' of a drawing will be different for every artist and, as in speech, may convey more than the 'words' themselves.

A drawing can be thought of as an end in itself, or as a means to an end. As a work of art it should be satisfying aesthetically in the skill of its handling and composition, at the same time revealing the artist's insight into the subject – form and content linked together. As a tool for learning, drawing is a valuable visual aid. It is an exploration of

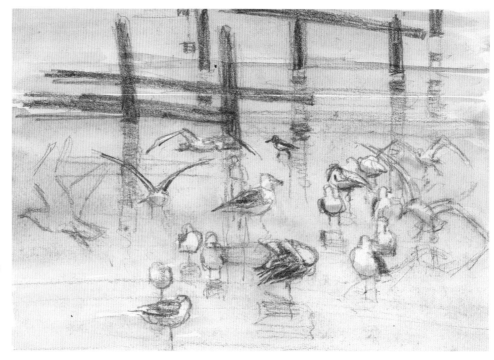

possibilities, an aid to memory and a way of testing the water. Most of us at some time will have scribbled a sketch-map to guide a visitor, or made a diagram to show someone what we have in mind for a particular project. A drawing can be a quick reminder of some event, such as an addition to a letter or a diary or a nature notebook. (My father always laced his letters with matchstick men enacting encounters with the neighbours – highly graphic and humorous drawings using very few lines.) It is amazing how quickly the eye will pick up meaning in the barest suggestion. A few straight lines can become a tree or a building; a circle can turn into a wheel, the sun or a person's head. The old cliché for a flying seagull is instantly recognisable – everyone can draw that. Inventing your own expressive shorthand can be a good first step towards more sophisticated drawing.

Many naturalists keep field journals, augmenting written notes with sketches and diagrams. Most people would agree that notes made at the time are the most reliable ones; so it is with drawings. When in the field, forget the finished picture and record what you see as simply and directly as you can. There is growing interest in the United States in what Clare Walker Leslie calls 'Nature Journalling', using the sketchbook as a diary – drawings combined with written thoughts. She is a pioneer of using drawing as a tool for learning, and I recommend her

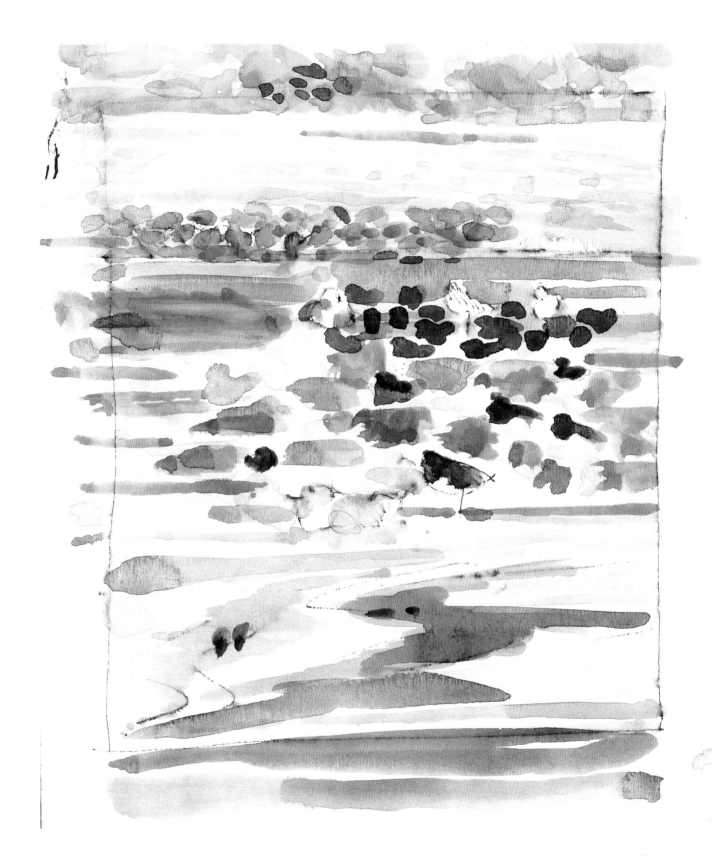

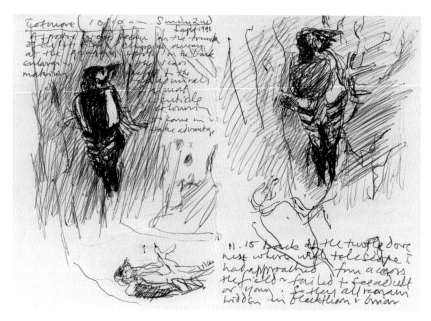

books on the subject, along with some others.[1-5] Adding written notes can increase your powers of observation and refresh your memory about dates and times and places. Too many words can dilute a drawing. Ideally, a drawing should be able to express everything unaided. If you add words, let them say something not implied by the drawing.

Encounters with wild birds are usually measured in split-seconds, and one is rarely given another chance to react. Latching on to what is important comes with experience. It does take time to learn to draw quickly and a good memory and a high-speed response is something to cultivate. Even if you can't draw in an art college sense, there is much that can be done to sharpen observation and fix events in your memory.

The first step is to be prepared. I actually see more if I leave the house with sketchbook in hand and pencil at the ready, than I do if everything is packed away for a differ-ent occasion. You never know what surprises might be around the next corner. A pocket-sized or A4 notebook or sketchbook will suffice. Use a bound one so that paper does not tear off or blow away, tinted perhaps to avoid the sudden exposure of a white page to nervous birds, and with an inconspicuous, hard-backed cover, as waterproof as possible. Pages can be held down by clips or elastic bands so that the book opens without flapping, ready for action.

Draw with whatever moves quickly over the page. I prefer a soft pencil, 4B to 6B, a fine black felt-tipped pen or a sharpened conté pencil. (A pencil sharpener is a must, and I use mine as frequently as a snooker player uses chalk.) Don't be tempted to take an eraser. Attempting to rub out wastes time.

David Measures uses a child's multi-coloured ballpoint pen to great effect, smudging the colours with a licked finger. Some felt-tipped pens run slightly when a wash is added, giving a bluish colour. With a

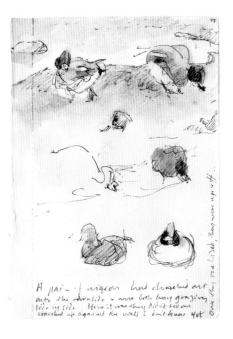

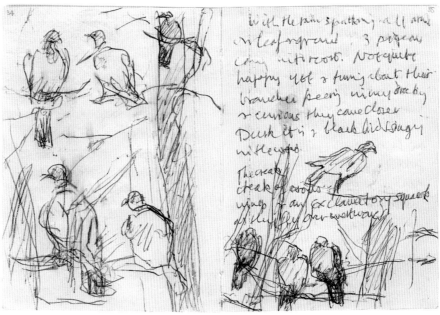

▶

Eric Ennion
Dunlin resting
pencil

*Characteristic poses –
compare with Curlew
Sandpipers in the lower
drawing. The wader
stretching its wings is a
Little Stint and the vertical
lines relate to the position
of reflections (more on
this in Chapter 5).*

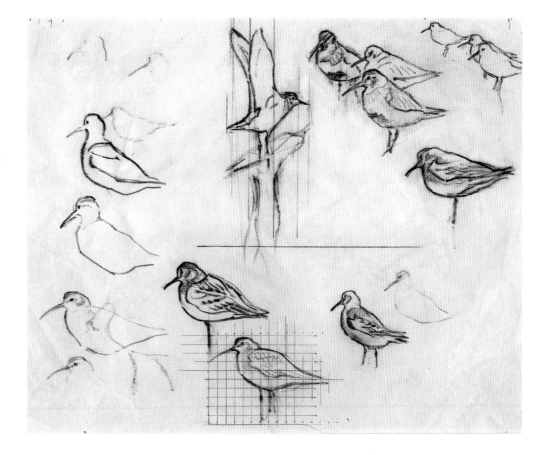

Michael Warren
*Willow and Blue Tits
moving through brambles
with a small party of Long-
tailed Tits*
coloured crayon

*Crayons are a useful dry
medium for the field,
retaining the quality of
drawing with colouring.
Greater intensity of colour
can be gained by applying
more pressure with the
crayons, and one colour
can be superimposed on
another.*

▼

sepia wash on a brush picking up the cooler colour of the ink you can lay in warm and cold areas in one go.

Ink is a good learning medium because it is committed. You cannot rub out, though you can overrule with even blacker lines. Also, a pen moves more quickly than a pencil. A black ink line is so unlike the actual edge of whatever you are looking at, that is easier to understand that drawing is a translation from one reality (that of the bird), to another (that of the drawing).

The 14th-century artist Cennino Cennini, who had been taught in the tradition of the great Giotto, wrote a delightful treatise on artists' methods. [6] On the value of ink drawing, he said, 'Do you know what will

happen if you practise drawing with a pen? It will make you expert, skilful, and capable of much drawing out of your head'.[6] A soft pencil or crayon that makes strong committed marks is equally good.

Artists often use tone (shading) to look for the light and dark pattern of a scene, before pulling the forms together with line, 'blocking-in' areas of shading to reveal the light. A drawing of a bird against the light could begin *within* the bird's shape, shading out towards the outline rather than the other way round.

It takes rather more courage to start off a drawing with a brush and a wash of either ink or watercolour, but it is a delightful medium that can cross boundary lines of

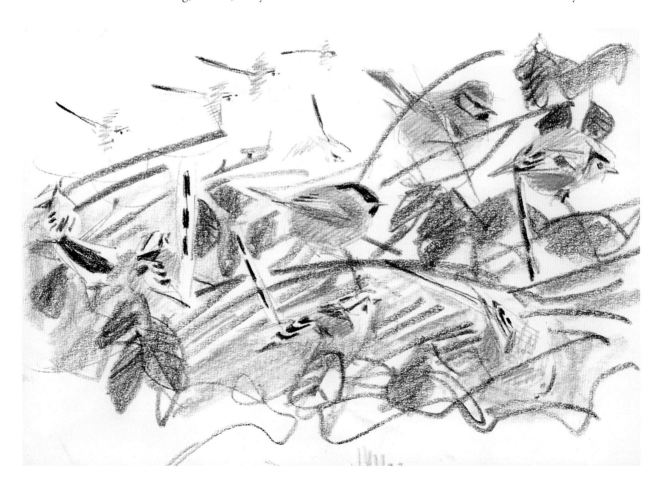

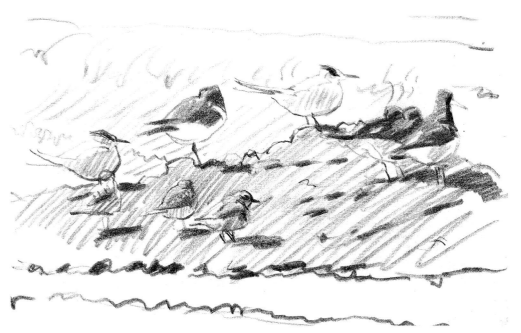

shape and unify areas of tone. This is the best method of all for learning to see.

Each medium sets the eye off in a different direction. It is very enlightening to make several drawings of the same thing – perhaps a landscape, where you have no pressure of time – changing the medium each time to see what each kind of mark draws out from the subject.

When drawing in the field it is better to suspend judgement and keep going, rather than to worry about the quality of your work. Often you have time for only a few lines – a reminder of some action. To attempt a bird portrait on the first encounter is unlikely to succeed. Eye, hand and brain need to acclimatise. Killian Mullarney says that he often sees young enthusiastic observers poised over their telescopes with notebook on knees, pencil in one hand and rubber in the other, trying hard to complete a portrait. But every movement of the bird causes them to rub out more than they put down.

'I know how frustrating this can be,' he goes on, 'because I did it for years. Suggesting that they work quickly is of little use, because they often lack sufficient understanding of their subject to draw it quickly. What I have advised, and it seems to help, is that they devote the first half-hour to learning and, rather than attempt a bill to tail drawing straight away, to draw parts of the bird as they see them. They may end up with a page or two of bits and pieces, but if they then attempt an overall sketch it is likely to come more easily.' This is sound advice.

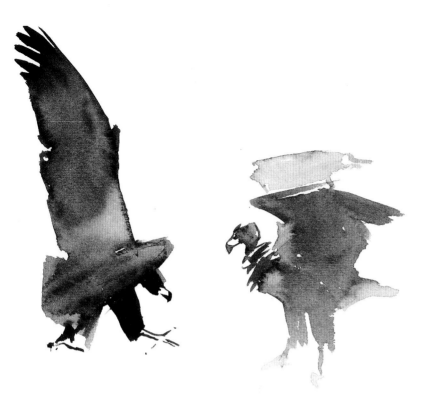

is. If you are watching a bird's behaviour, there is no need to complete a detailed study. What it is doing and where it is going can be suggested by using directional lines or arrows with undefined blobs representing the birds, more a diagram than a drawing – a kind of visual algebra. Using blobs of different sizes – small ones for, say, Dunlin or 'peeps' and larger ones for Curlew and ducks. With a few marks you can calculate great spatial equations and portray the bird distribution of an estuary.

Whatever it may look like to anyone else, your drawing can remind you of the birds' activities, about the shapes of their groups, and about distances and the scale of the environment – and thus set the pattern of it all.

Learning to see is also about making comparisons – seeing one thing against another. It is not difficult to show the scale of an object when there is something to compare it with. In a similar way, contrasting shapes or directions of movement make each more apparent. A bird may look more rounded next to an angular rock; water will appear to flow faster if a resistant boulder is introduced into the drawing. A Coot swimming towards a rival becomes more purposeful set against a group of

How then does one begin to see birds with 'sufficient understanding'? It is sometimes suggested that for drawing purposes, birds are basically egg-shaped, with a smaller egg for the head. This may be helpful when drawing a static side view bird, but it is rather an applied formula as birds can change their shape in a twinkling. I find it better to begin with some indication of what the bird is doing and where it

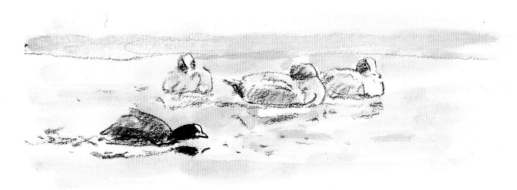

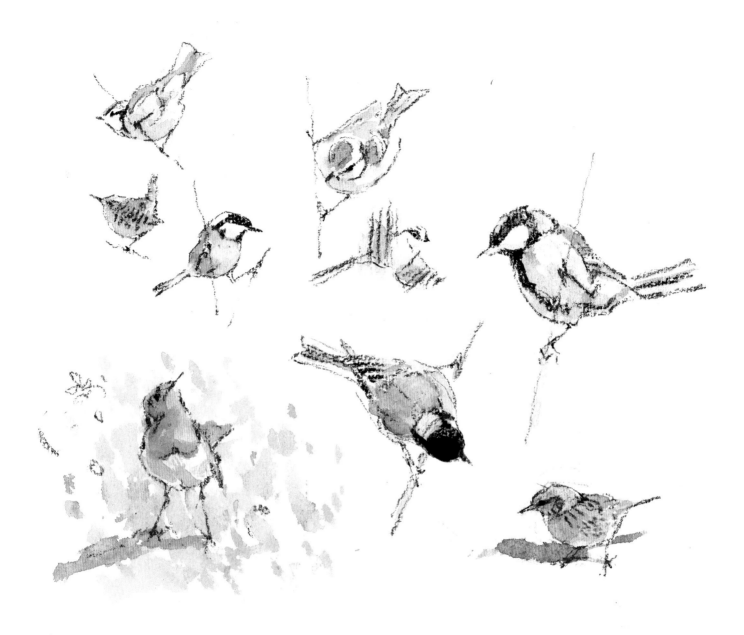

▲

John Busby
*Tits, Wren, Robin
and Dunnock*
charcoal pencil and
waterclour

*Birds seen from my house
window: poses where a
quick turn of the head
shows the birds' next
intention to move.*

resting Wigeon. In a diagrammatic way, the direction of sunlight, wind, water currents could be indicated – all part of seeing the whole scene and some of the 'invisible' forces at work.

Back to the shapes of birds. Most shapes (except squares and circles) have a dominant axis. Instead of trying to draw the outer edge of a bird's shape, try to see the angle of the bird's body. Is it level or tilted compared with the ground? A bird's body does not twist and bend like a mammal's body, so the axis remains straight and pivots on the angles of the legs. Movement can be suggested by the way these angles, and those of the head and wings, relate to each other.

A bird uses its bill for most of its actions on land. If it is feeding, the action begins with the thrust of the bill, and its body is

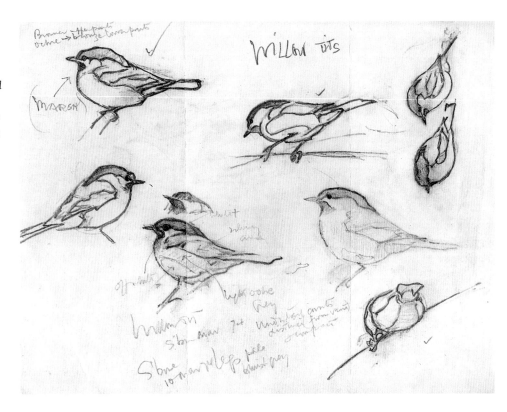

balanced to make this possible. There is a tension running through the bird affecting its outer shape – miss that and your bird will show only the appetite of a museum specimen.

Preening is also concentrated in the activity of the bill reaching to all parts of the body, but there is a relaxation in the body feathers. Preening postures lead to some of the most beautiful and unexpected shapes, but the important thing to look for is balance. (This is something you can sense far more from a living bird than ever from a photograph.) I have found it fascinating when looking at a mixed group of waders, for instance, to concentrate not on the different species, but on as many aspects of balance as I can find.

Drawing is a way of learning to see. Draw anything and you will know it better than before, even if the drawing is not up to much. You also begin to realise that your eyes are giving you varying information all the time. What you see after three minutes' drawing will be quite different from your immediate impressions, and from your understanding half an hour later, when your eyes have travelled over, through and around your subject many times.

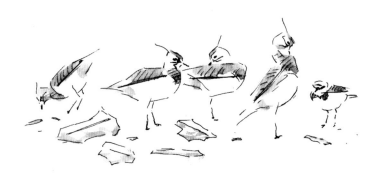

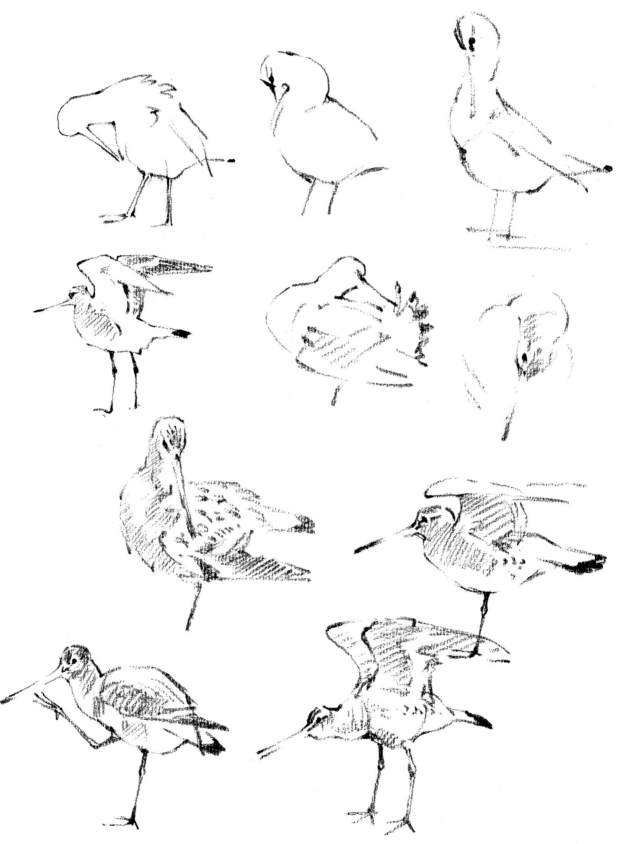

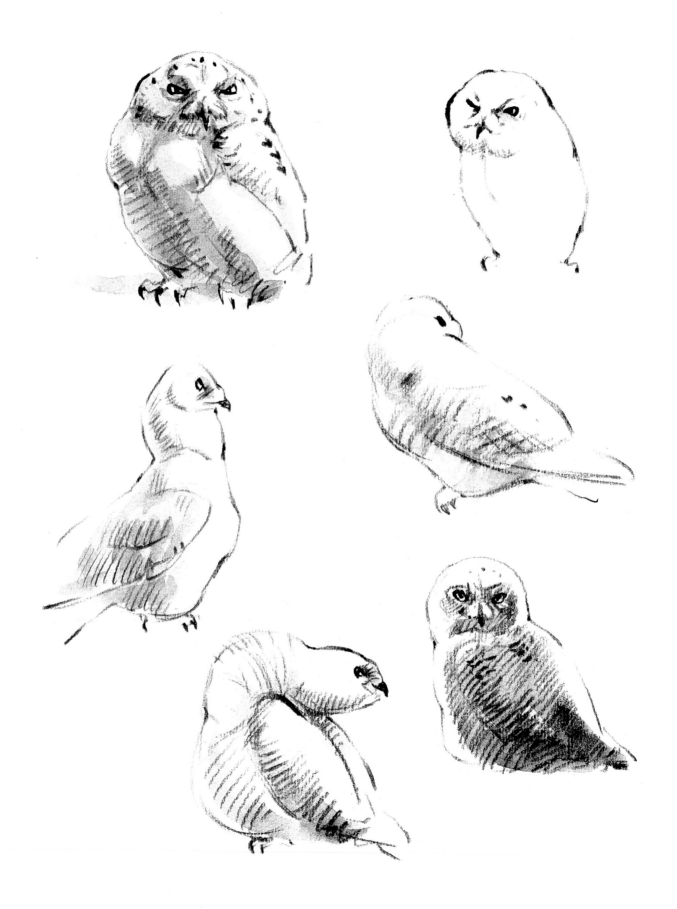

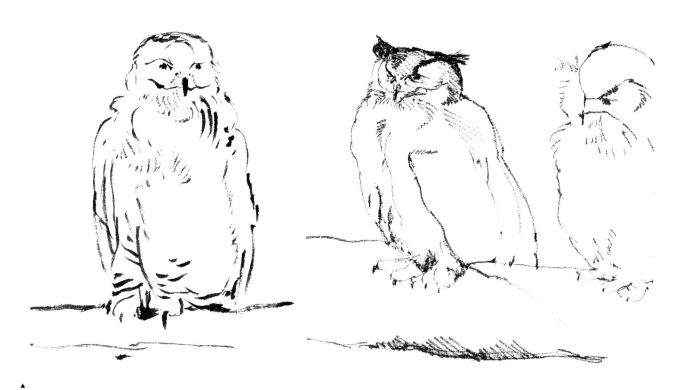

▲

Janet Melrose
Studies of owls
felt-tipped pen and brush and
ink

*Drawn with a felt-tipped pen
held loosely and mostly
using the side of the tip, and
with ink on a brush.*

▶

John Busby
Barn Owl
soft pencil and watercolour
wash

◀

John Busby
Snowy Owls
soft pencil and watercolour
wash

*Some of the many shapes of
Snowy Owls in the zoo –
internal anatomy completely
confused by feathers. These
are fairly accurate studies but
it can help to see essentials by
exaggeration and caricature.*

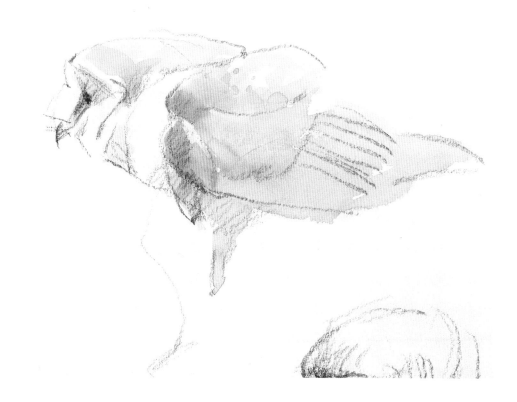

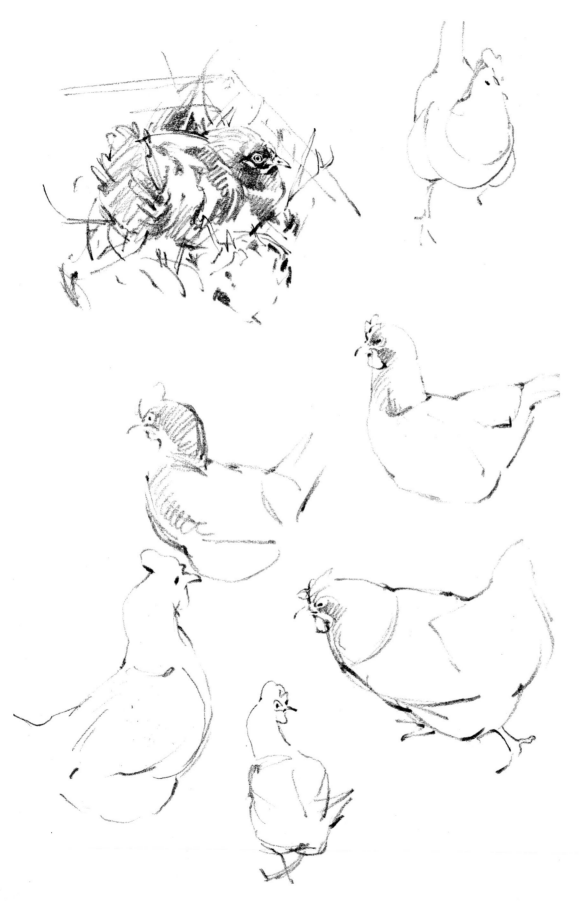

◄

John Busby
Studies of bantams
pencil

Domestic fowl offer the ideal models for anyone drawing birds. They are chunky so that the form can be easily seen. They do not move very fast, and they are full of character. These birds were drawn on a farm in Crete.

►

John Busby
Great-spotted Woodpecker
carbon pencil and watercolour

This woodpecker was a very shy visitor to the nut feeder. Being only four feet away behind glass, I only began the drawing after it had flown away, trying to remember its posture and the striking black, white and red markings. Compare with Keith Brockie's drawing on p. 49.

►

John Busby
Tits at a nut feeder
pencil

The feeder hangs on wires stretched below a balcony – ideal perches for birds waiting their turn. Once I had placed a couple of birds, the drawing began to suggest where to put the next bird. Pretty soon the right one would arrive. So already, in the initial stages of a sketch, choices are being made instinctively.

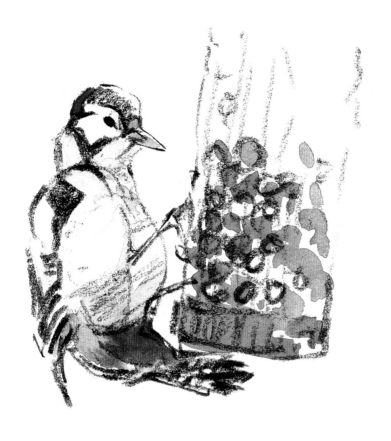

Drawing is like the unravelling of a mystery, a search for the true nature of an experience. Such drawing, which is not often seen outside the artist's studio, can be far more exciting to read than a carefully finished picture, where the process of creation is no longer visible. The sketch-books of Leonardo, of Constable, Braque, Andy Wyeth, Henry Moore, or Fuertes and Tunnicliffe, are rightly prized for the light they shed on the artist's thoughts in the search for expression.

Art students have found it difficult enough to come to terms with what was called in my student days, the 'significant form' of a still life or a model posing for hours, without having to cope with a subject that prefers to be out of eye-shot. So be patient; it may take years of practice to discover enough about the ways of birds and the ways of drawing to bring both together with conviction.

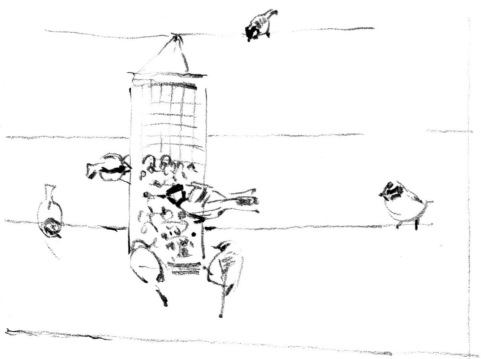

1. Nature Drawing: A Tool for Learning, *Clare Walker Leslie, Prentice Hall, 1980.*
2. The Art of Field Sketching, *Clare Walker Leslie, Prentice Hall, 1984, reprinted Kendall Hunt, 1995.*
3. Nature Journalling, *Clare Walker Leslie, Storey Books, 1998.*
4. A Trail through Leaves, *Hannah Hinchman, Norton, 1997.*
5. In Season, *Nona Bell Estrin & Charles W. Johnson, New England, 2002.*
6. Il Libro dell'Arte, *Cennino Cennini, translated by David V. Thompson, Dover Publications, Inc., 1960.*

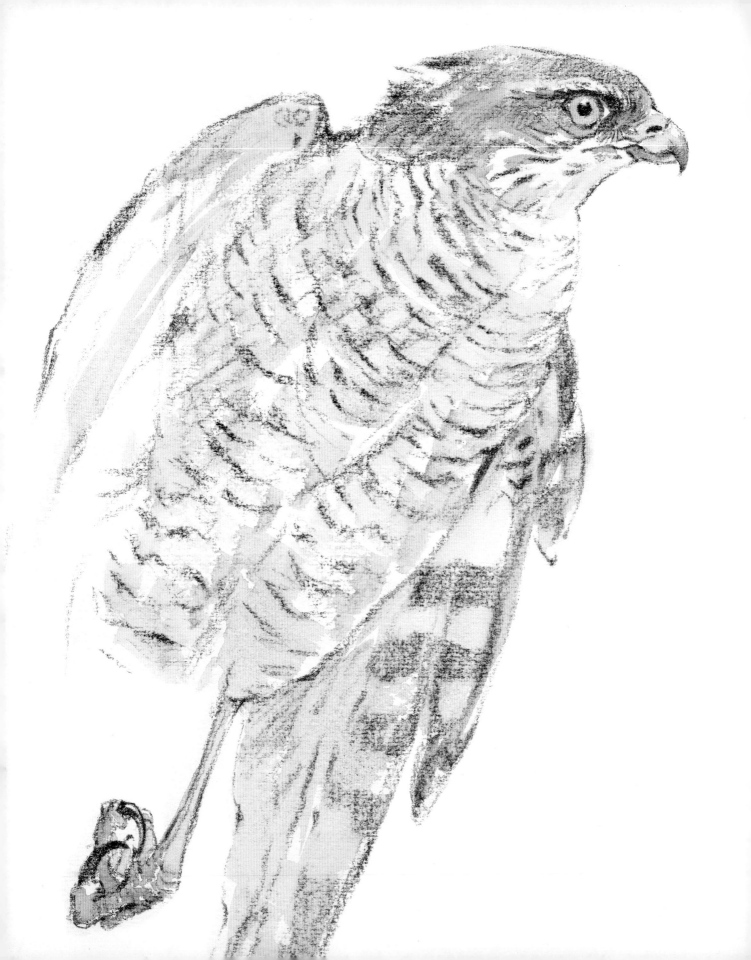

3 Birds in the Hand

◀

John Busby
*Study of a dead
Sparrowhawk*
conté pencil

In the previous section I suggested ways of developing a quick drawing response to what you see before necessarily acquiring specialised knowledge of the birds you are watching, or great skill in drawing. These attributes will grow with experience. I suggested watching behaviour as a key to understanding birds from a drawing point of view, beginning with those that are familiar and can be watched without difficulty. However, drawing is undoubtedly easier when there is knowledge to back it up.

To understand any living creature and how it moves, you do need to know what lies beneath the surface. You need to be familiar with the basic anatomical structure of a bird's body, and also how the feathers that form the surface plumage are grouped together. In time this knowledge will become second nature, informing your seeing and raising the level of your drawing.

In some ways a bird is a simple form when compared to an animal. Most of its bones and muscles are out of sight behind feathers, and there are fewer basic differences in form within the range of species than

▼ *Major bones and
Feather tracts of a Thrush*

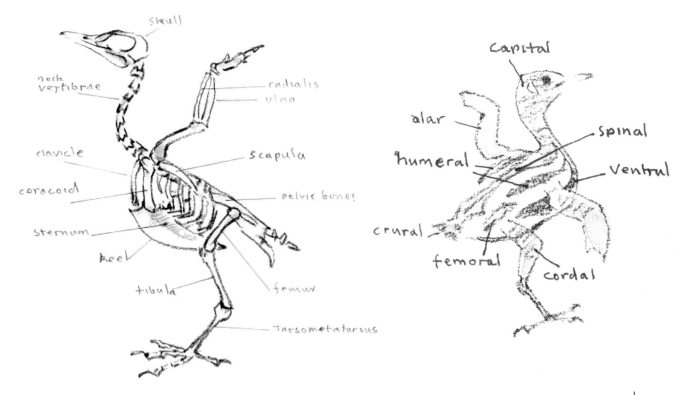

there are among mammals. However, birds can change their outer shape disconcertingly at times by fluffing out their feathers or pulling them in tight to the body.

In detail, the bones of the body need not concern the artist, though they are as fascinating as those of any creature – light and finely moulded for strength. Pelvis and back vertebrae are fused into an almost rigid structure to give strength for flight, and to help the bird to balance on two legs. These hidden bones can be sensed by a single axis line as I suggested earlier, but there is an equally important part of the body structure to be aware of – the keel or breast-bone, together with the strong tripod of bones linking it to the shoulders. Here we find the heaviest bones in a bird's body, the coracoids, and the familiar wishbone. (For simple drawing purposes these bones can be represented by a halter-like oval forming the bird's chest.)

Attached to the keel are the powerful flight muscles, those that lift and depress the wings. (The lifting muscles, the minor pectorals, work through a pulley-like hole – a unique feature of birds – between the shoulder bones and are attached to the top of the humerus.)

The rigid vertebrae of the body give way to a very flexible neck that contains, not the seven bones of all mammals, but a variable number. Most birds have 14 neck vertebrae, though swans, for instance, have 23. The neck can be stretched or folded into an S-shape to bring the head close to the body, enabling the bird to use its bill to fulfil the various functions of preening, feeding and nest building.

In flight, birds present an amazing range of movement and angles of view. The wing bones are not unlike those of a human arm,

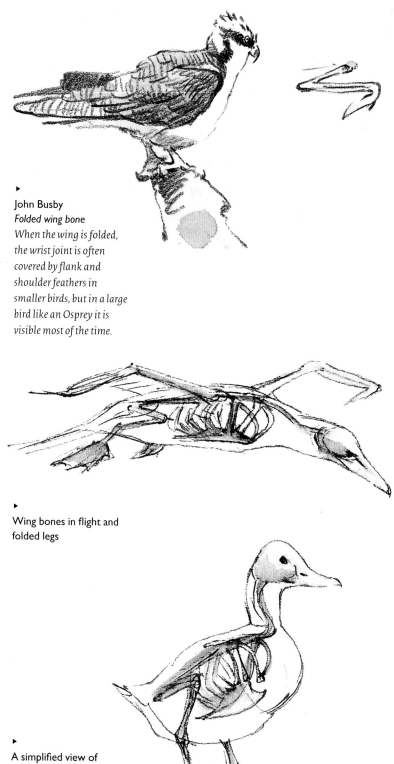

▶

John Busby
Folded wing bone
When the wing is folded, the wrist joint is often covered by flank and shoulder feathers in smaller birds, but in a large bird like an Osprey it is visible most of the time.

▶

Wing bones in flight and folded legs

▶

A simplified view of main structural bones of a duck.

and I will say more about them in the chapter on flight (Chapter 6). When not in use, the wings are neatly folded to the bird's side, leaving the long primary (wing-tip) feathers to overlap above the tail. Except in very large birds like herons or eagles, the rest of the wing is partially hidden by overlapping feathers on the shoulders and flanks. In larger birds the 'wrist' joint is often visible, as is the case when birds prepare for flight. A bird stretches its wings regularly, usually a wing and a leg on the same side at the same time. This is a beautiful action to watch.

On land, the legs are all important, and here the hidden bone structure is vital to an understanding of balance. All back legs spring from a pelvis of some kind. That of a bird is not big and boney and leaves no bump on the surface, but you need to sense the hidden starting point of the legs quite far back along the axis of the spine. If you imagine a crouching person, there will be a zigzag from pelvis to the knees then back to

the heels and forward to the toes. You will remember from a chicken leg that the muscular 'drum stick' has limited movement and points forward. From knee to heel the bone articulates through 180 degrees, and though most of the shin remains behind feathers, and is feathered itself over the muscular part, you can usually see enough of an angle above the heel to guess the whereabouts of the knee. It will do no harm in your sketches to put in the hidden zigzag whenever you draw legs until you can balance a bird with absolute assurance.

The knobbly ankle joint is difficult to see clearly in the field, and it is useful to make studies from tame or dead birds in order to understand it. In the foot, the tarsal and metatarsal bones are fused as far as the toes, with a strong tendon running down the back. On the shanks of the legs and feet, feathers usually give way to scales, owls and some game birds being among exceptions. There are large scales down the front and

▼
John Busby
Leg positions in feeding waders

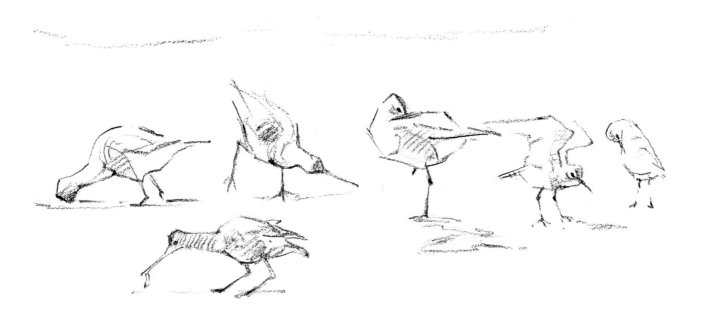

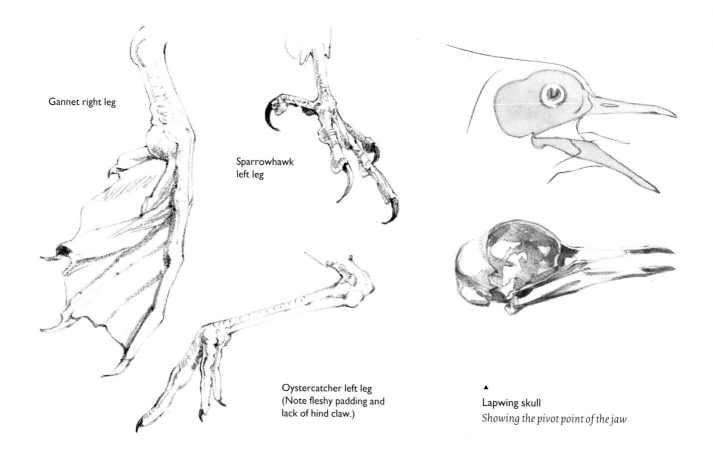

Gannet right leg

Sparrowhawk
left leg

Oystercatcher left leg
(Note fleshy padding and
lack of hind claw.)

▲
Lapwing skull
Showing the pivot point of the jaw

▲ ▼
John Busby
Legs
Gannet, Sparrowhawk, Oyster-
catcher and (below) Tawny Owl.

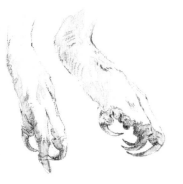

smaller ones on the sides and back. In swimming birds such as grebes and cormorants, the tarsus presents a narrow surface to the water and is broad in side view. Birds' feet, like their bills, are enormously varied in shape and function. They are not easy to draw and one should not assume one bird's foot is like another's. You will come to know each species' peculiarities as you draw them.

Most birds have four toes, with the usual arrangement of three in front and one behind. Some running birds have very small hind toes or have lost them altogether. Pelicans, cormorants and Gannets have all four toes webbed. Woodpeckers can bring their outer toe to the rear to give two in front and two behind – an advantage on a vertical surface. Kingfishers and bee-eaters

have forward toes that are only partially separated.

Whatever the toe formula, the number of joints in the toes remains the same – the hind toe has two, the inner three, the centre toe four and the outer, usual the longest, five. The bones reduce in size as they increase in number. This gives a more flexible outer toe for wrapping around a branch, and a strong, hook-like rear toe to anchor a bird when perched. The tendon automatically locks the feet when the leg is drawn up to the body. In flight the feet may be drawn up under the body clenched, or stretched out under the tail. (Remember, even then the knees point forwards.)

The most active part of a bird is its head, carrying those ever alert eyes and the beak,

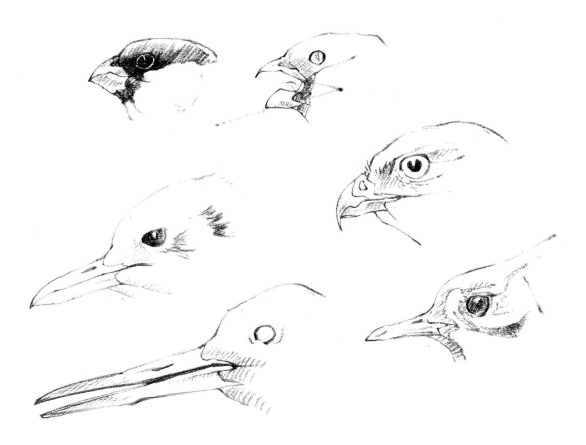

its all-purpose precision instrument. The skull is shaped rather like the pumice stone you use in the bath. It tapers to the beak and is broadest at the apex of the eye socket just behind the eye. This socket is large for the proportions of the skull, and one can often see the presence of the ridge of bone above the eye. The change of form here from top of head to side is most abrupt round the eye. There is often a noticeable eyebrow, emphasised by light and shade and particularly obvious in a gull or an eagle.

The shape and position of the eye is a vital clue in setting the angle of the head. As the head turns, the eye becomes more elliptical. Spend some time with tame birds just drawing heads and eye placings. Highlights can help to show the convex surface of the

eyes, but they need careful observation or they will become mechanical additions: one does not always see a highlight in the field. Above all, a bird's eye should express an outward-looking energy.

Beaks come in all shapes and sizes, designed for a bird's feeding habits rather than for their other many uses. In the field, quite subtle differences between the beaks of closely relates species – sandpipers, for instance – can be critical factors in their identification. When the beak is open, the jaw is hinged beyond the visible gape of the mouth, towards the base of the skull. Too often one sees an open beak drawn like an Easter chicken, or completely unhinged. Some birds have a degree of flexibility in the upper mandible. This is very noticeable in a

▲

John Busby
Heads
Bullfinch (showing hinge-point of Jaw), Kittiwake, Sparrowhawk, Oystercatcher and Lapwing.

parrot, for example, and even a long-billed bird like a snipe can flex the tip of its probing beak. The eye must always be placed above a line between the upper and lower mandibles, but watch out for a change of angle in birds with very hooked beaks.

Feathers do not grow evenly from the skin of a bird as hairs do from animals. They grow in clusters from tracts or pterylae (see p.41). The tracts are found covering the head (divided into sub-units), running down the spine and over the pelvis to cover the back and rump, and running on each side of the body to cover the upper breast and flanks. Another tract produces the scapular feathers, which cover the shoulders; another feathers the ventral areas, and yet other tracts give rise to the wing and tail feathers

and those covering the legs. Between the tracts there will be either down feathers or bare skin.

The fact that feathers form groups makes drawing easier. However beautiful and complicated a bird's plumage, make sure of the feather masses before drawing individual feathers. The edges of these masses are often marked by a change of pattern or colour, which makes them easier to see. Head feathers are usually small but a bird may carry a crest or a ruff. Feathers on the forehead may be raised in display, and those on the throat in song. Neck feathers give an impression of bulk, but this is an illusion. When a bird draws its neck into the body, the feathers seem to dissolve into each other but they move with the neck and swivel

▼
Robert Greenhalf
Rooster studies
soft pencil

Drawn with lively flowing lines that express the elegant poise and busy interactions of this group of fowl.

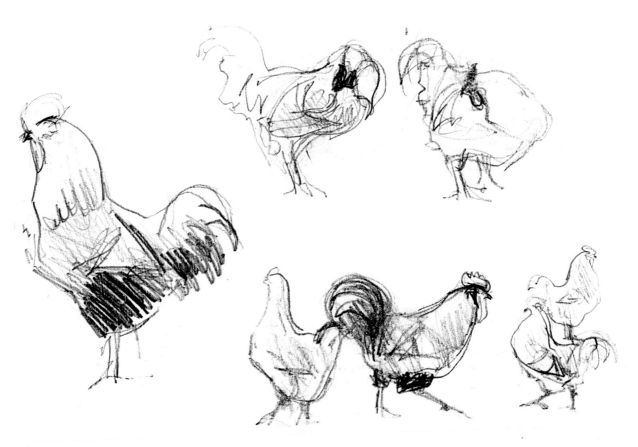

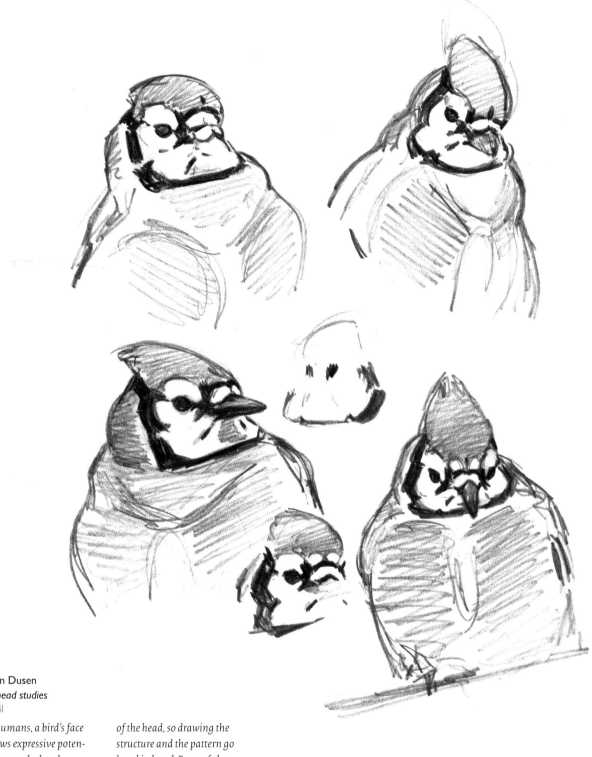

Barry Van Dusen
Blue Jay head studies
soft pencil

'As with humans, a bird's face often shows expressive potential, so observe the head carefully, paying special attention to facial 'expression'. Patterns on the head usually correspond to the feather tracts of the head, so drawing the structure and the pattern go hand in hand. Be careful, however! In some species patterns run across the boundaries of feather tracts, serving to obscure the forms beneath.'

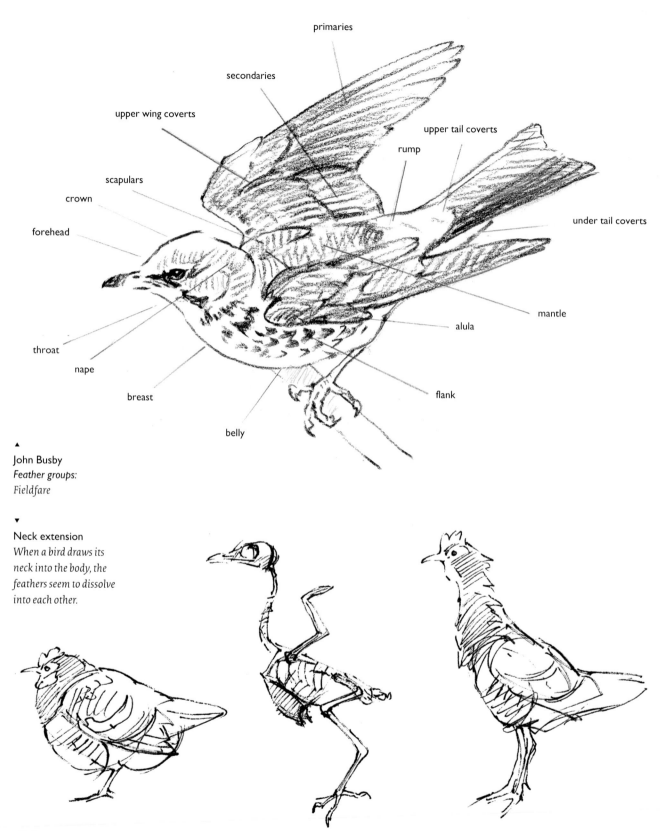

primaries

secondaries

upper wing coverts

upper tail coverts

rump

scapulars

crown

forehead

under tail coverts

throat

mantle

nape

alula

breast

flank

belly

John Busby
Feather groups:
Fieldfare

Neck extension
When a bird draws its
neck into the body, the
feathers seem to dissolve
into each other.

▶

Keith Brockie
Great Spotted Wood-
pecker on nut feeder
pencil

A drawing that from the
first light pencil marks
keeps a tight hold on the
solid form of the bird, so
that all the markings and
the shape and position of
the eye confirm the inner
structure, and when the
bird allows more time,
such a fine degree of detail
is possible.

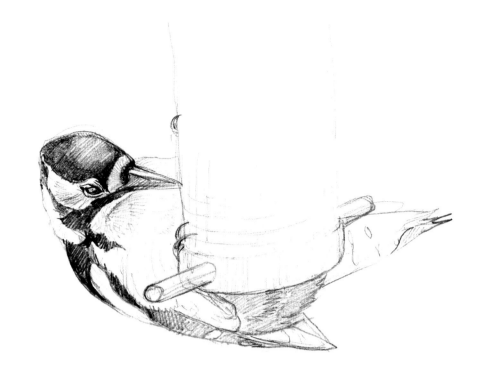

against the body feathers as the neck turns. This is very noticeable in a domestic fowl or an owl, and is one of the most important lines to look for when drawing, as the elliptical section it gives will help to make a bird look solid. (Ellipses create the illusion of circles turning in space, so if you can draw circles from any angle, you can draw almost anything!)

Once the main body feather masses are understood as groups, it is easier to see both the behaviour and solidity of a bird and the true garment-like purpose of all those hundreds of individual feathers. A bird preens in order to make each feather a part of the whole covering, so there is no compelling reason for the artist to do the opposite and paint them one at a time.

Studies of dead birds are an important part of learning the finer details of a bird's body, especially feet and bills, and the subtleties of plumage not so easily seen in the field. So take advantage of every opportunity to draw a freshly dead bird. The studies from dead birds by Dürer, Pisanello and, of course, Tunnicliffe are works of art in their own right. I think a dead bird should look dead and take whatever form is appropriate to its resting place.

In time a knowledge of the essential anatomy of a bird becomes an intuitive part of seeing and provides the key to drawing a bird in any position with conviction.

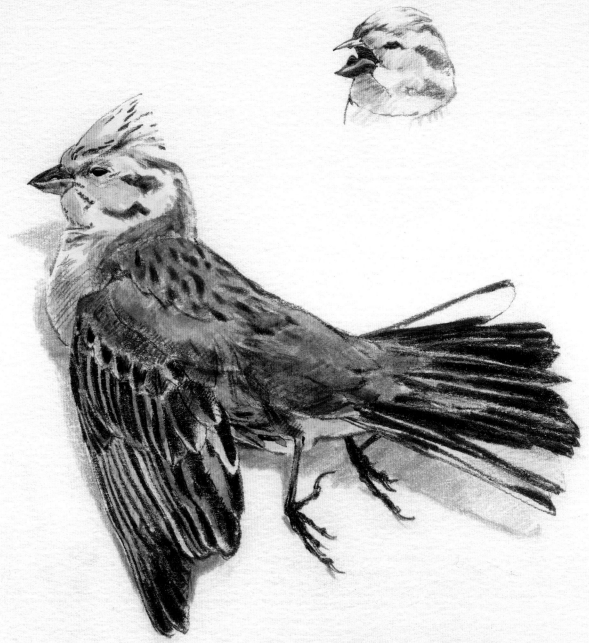

♂ Yellowhammer June 85

▶

Killian Mullarney
American Bittern
watercolour

'Painted from a freshly
dead bird caught by a dog
in Wexford, Eire, in
January 1990. It was a
really beautiful bird and I
felt compelled to paint it.'

◀

John Busby
Cock Yellowhammer
watercolour heightened
with coloured crayons

Artists today do not shoot
birds to study them and I
would never wish one
dead, but finding a freshly
dead bird gives an oppor-
tunity to make detailed
drawings of beaks and feet
and to note plumage
patterns and colours.

▶

David Koster
*Life-size studies of a dead
Great Northern Diver*
black ink and wash

Found on a beach, west
coast of Scotland.

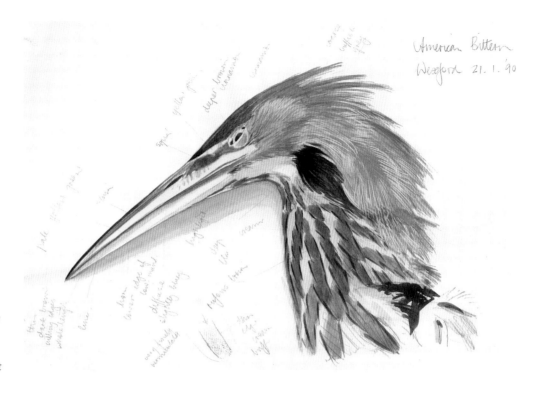

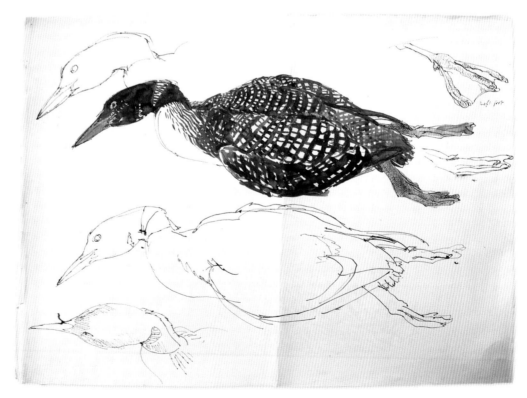

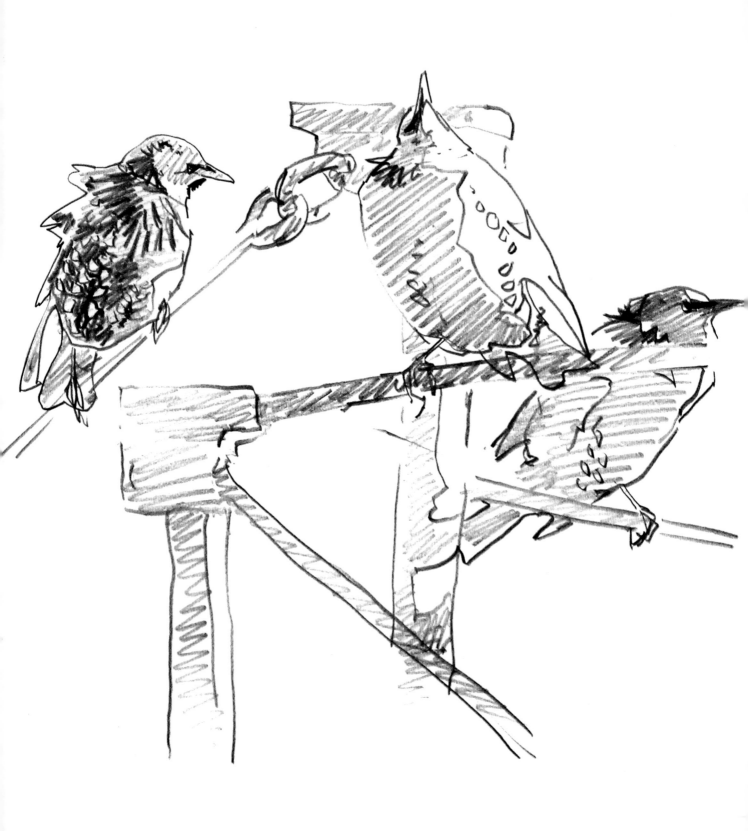

4 Birds in the Bush

◄ ▼

Darren Woodhead
Starlings
pencil

*Common birds are no less
interesting than rarities,
and watching their
behaviour is the best
preparation for more
ambitious fieldwork.
'These starlings sat on a
junction of aerial wires in
late afternoon light all
looking different ways. I
tried to show the strength
of light by marking the
demarcation line clearly
where the shadows
began.'*

Draw from tame or familiar wild birds to begin with. The better you know a bird, the more confidently you will be able to respond to it. Birds seen fleetingly through binoculars are best ignored until you have more experience and can retain a lot of what you see in your memory.

Any occasion where a situation is frequently repeated, will give more chance for your drawing fragments to turn into completed birds, for example, birds at a winter feeding-table, which can be watched from a window; ducks coming for food on a park lake or gulls to a fishing harbour. Wild birds attracted to a local farm or a zoo by easy pickings are less timid than usual, and you can watch many birds without taking

extreme measures to conceal oneself. Birds will often ignore a car, which can make a comfortable, if not very manoeuvrable, viewing hide, with the advantage of support from partly wound-down windows for binoculars or telescopes. (You can buy telescope brackets that attach to car windows.)

Hides (blinds) provided by organisations like the RSPB on nature reserves are a godsend to the artist, but to me, there is nothing better than sharing the birds' environment (and weather conditions, even under an umbrella), where one can be alert to sounds and to movement seen out of the corner of an eye, and open to the unexpected. A bird artist has all the excitement and frustrations of a hunter, and the need for similar subtlety of field-craft. It is counter-productive to pursue birds. However careful you are as a stalker, you can be certain that the birds have seen you coming and know just how close they will let you approach. It is far better to sit and wait for birds to come to you or to walk towards them casually, avoiding stealth. Birds wake early in their search for food, and you will usually see more activity between dawn and breakfast than at any other time of day. As your field knowledge accumulates, the odds against seeing wild birds close enough to draw can be shortened.

Many patterns of behaviour – courtship, breeding, flocking and migration – are predictable and vary with the changing

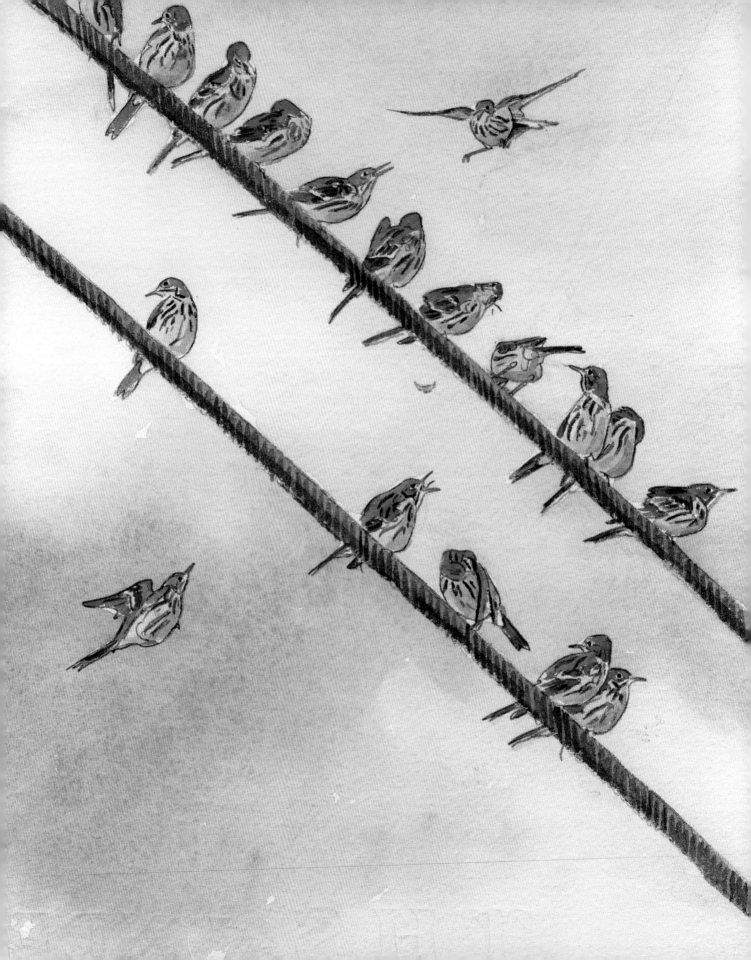

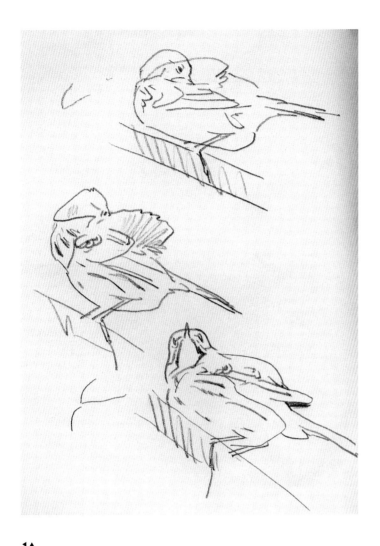

◂ ▴

John Walters
Meadow Pipits gathering to roost
watercolour & drawings

'*I found a roost site on my way home from work and began sketching as the birds sat preening on wires before going to roost. I thought I would grow tired of drawing the same birds every day, but the more I drew the more I saw and realised that there was much going on which I had not noticed before. I used to sketch for about 30 minutes before it got dark each day, drawing quickly. As the pipits were so active, preening, resting and squabbling, I found it best to concentrate on certain poses and* activities, e.g. head scratching. I learned more about drawing in the first few weeks of these studies than at any other time in my life. By going back to the subject again and again I became totally absorbed, the drawings got better and I attempted poses previously beyond me. On one occasion a pipit froze and stretched itself along a branch like a banana – a few seconds later a Hen Harrier appeared over the heather a couple of metres away. It was as startled as I was and flew off in a panic. Memorable moments such as this, and the ability sometimes to capture them on paper is what I love about field sketching.'*

seasons. For example, on the sea-shore or estuary, the tide is a considerable factor in knowing what is likely to be seen and where to position yourself. Waders may be scattered far and wide at low tide, but will be driven close inshore to favoured resting places at high tide. You can arrive ahead of time and wait, keeping below the bird's skyline, if possible in the shelter of rocks or dunes with the sun behind you. An incoming tide will also encourage seaducks, grebes and divers to follow sand-eels closer to the shore. A feature of winter activity is roosting; thrushes, finches, Starlings and many other species will gather at dusk, forming large flocks to spend the night together. Geese and Rooks follow regular flight lines between roosts and feeding areas.

In summer, a woodland clearing, especially near water, is a good waiting place. (We are not the only creatures to enjoy sunshine and shelter from the wind.) A tree at your back may be enough cover; stillness matters more than camouflage but you should avoid conspicuous colours at all times. Woodland birds are often curious, and will sometimes peer at you closely through the leaves. They can be attracted by imitating 'clicks', or what is known as 'pishing'.

The golden rule at all times is to keep a low profile and to let the birds get used to you as a harmless presence. One must always respect the privacy of nesting birds. It is only at a crowded sea-cliff colony that you can watch and draw from a fairly close distance without causing disturbance. (In Britain, disturbance at or near the nest of species listed on Schedule 1 of the Wildlife and Countryside Act, 1981 is a criminal offence.)

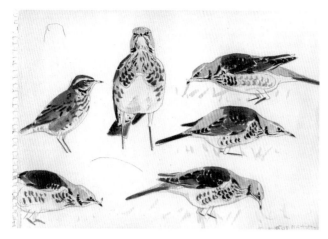

◄▼

James McCallum
Fieldfares
watercolour and studies

'A group of nearly 100 newly arrived Fieldfares feeding on a village football pitch. Over the next three days, as they became more familiar to me in their actions and plumage, I began to make some paintings. Once the local Sparrowhawks discovered them, their presence became more erratic and they soon moved on.'

►

Barry Van Dusen
Studies at a heron rookery
pencil

'Active nest colonies are a boon to the bird artist. Not only are the inhabitants predictable in their comings and goings, but some of the most dramatic and interesting aspects of bird behaviour can be followed from nest building to raising young.' These drawings were done through a telescope at a Great Blue heronry.

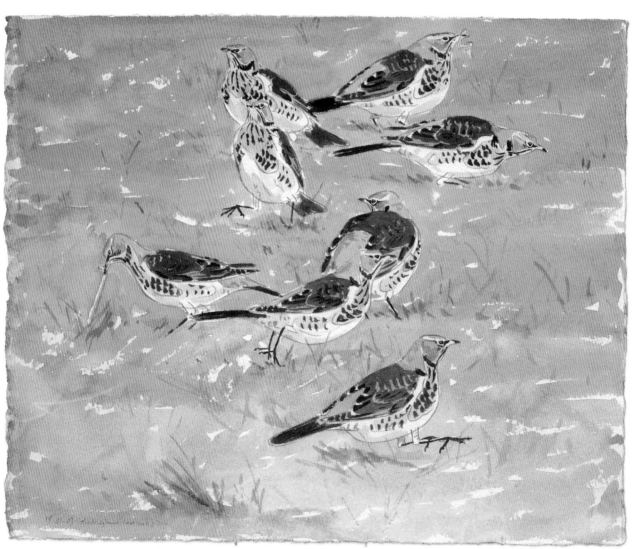

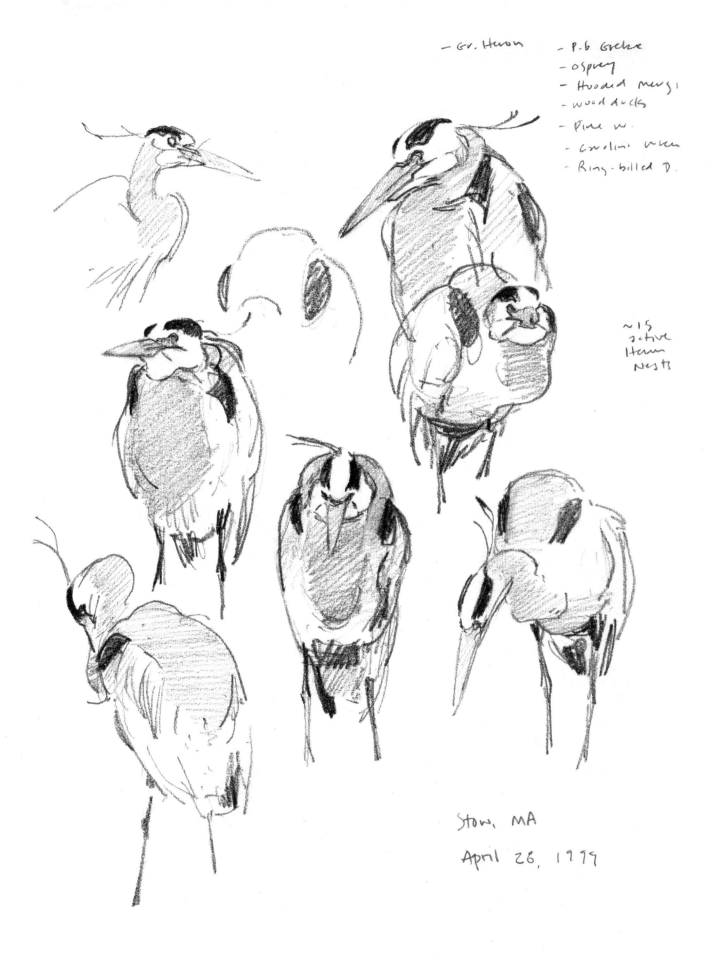

— Gr. Heron – P.B Grebe
 – Osprey
 – Hooded mergs
 – wood ducks
 – Pine w.
 – Carolina wren
 – Ring-billed D.

~15
active
Heron
Nests

Stow, MA
April 26, 1979

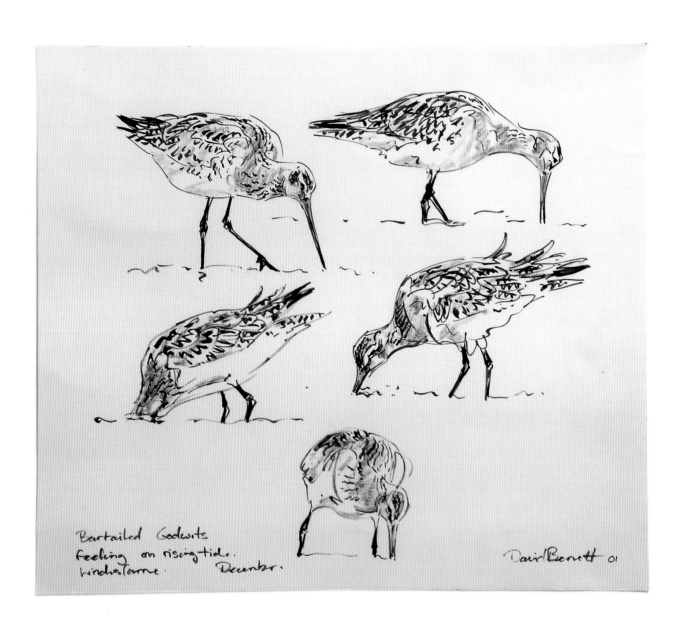

Bartailed Godwits
feeling on rising tide.
Winchelsea. December.

David Bennett 01

▲
David Bennett
Bar-tailed Godwits feeding
brown crayon & wash

Drawings that convey the energy of godwits feeding, constantly probing the mud for lugworms – their bills like delicate pile-drivers – heads often under water.

Binoculars are necessary for watching birds at any distance at all. Ideally, they should be easily adjustable for focusing and not too powerful (×7 or ×8) and light in weight. Miniature binoculars are very good in woodland where there is much looking up into trees, and they weigh next to nothing around your neck. Larger models may need the support of a tripod or simply a stick. The drawback of binoculars is that you need both hands to hold them, so for any sustained watching from one location, it is a great advantage to have binoculars independently supported. A tripod-held telescope gives even greater magnification though the field of view is considerably smaller. Most artists prefer to use a telescope with an angled eye-piece rather than a straight-through model, as it gives an uninterrupted view forward, and your head

is in the right position for drawing with a sketchbook on your knees. I find it quite difficult to look through a telescope with one eye, then quickly adjust to using both eyes when drawing.

A telescope's greater power means that you can stay further back from the birds and often watch behaviour that is un-affected by your closer presence. If you have seen photographs taken through a tel-ephoto lens, you will probably have noticed that distant birds in a flock appear larger than nearer ones – the opposite of our normal perception – so be aware of this distortion when you are drawing. Another factor to bear in mind is that binoculars and especially telescopes are usually focused with the bird in the centre of the circle. If you watch birds only by these means, the way you compose pictures can be affected.

Artists will have different reasons for drawing in the field. The keen ornithologist will no doubt want to draw primarily to record observed behaviour or to establish identification details relevant to each species. There is much to be learned from direct observation which cannot be under-stood from photographs or museum specimens, above all about a bird's 'jizz', that is its particular field characteristics. Differences in jizz can be very subtle but quite distinctive, particularly among

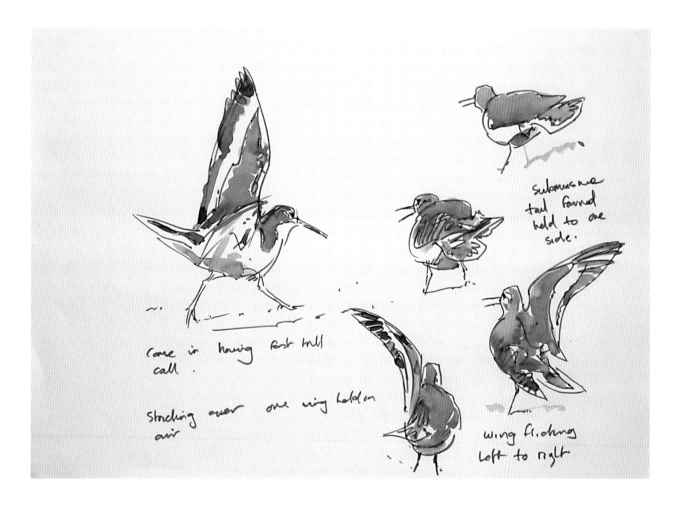

Darren Woodhead
Blue-headed (Yellow)
Wagtail studies
pencil & watercolour

'A drawing working out
the shapes of wagtails
perched and walking.
Once a bird stayed still
long enough, I added
colour to the sketch.'

waders and ducks. One species may be distinguished from another simply by the way it feeds. A thorough knowledge of common birds is the best way to be ready for a rarity when one comes along.

Plumage differences you see in the wild are seldom so simple as those usually shown in picture books. They are changed by different qualities of light and vary with age, seasonal moults and overlapping stages between. Look at the drawings of Lars Jonsson, Barry van Dusen, Keith Brockie, Darren Woodhead and Killian Mullarney, and you see their ability to select important features both of jizz and plumage of the individual bird in front of them, and to leave out what they know but cannot see on that occasion.

Other artist/naturalists might be moved by a rarely seen moment rather than a rare species. A common bird doing something never observed before is just as exciting to me as a rarity. Well, if I am honest, it is better than a rarity that is too far away to draw. As Killian Mullarney finds, there is often a tug between the urge to hunt out a rare bird, and the greater drawing potential

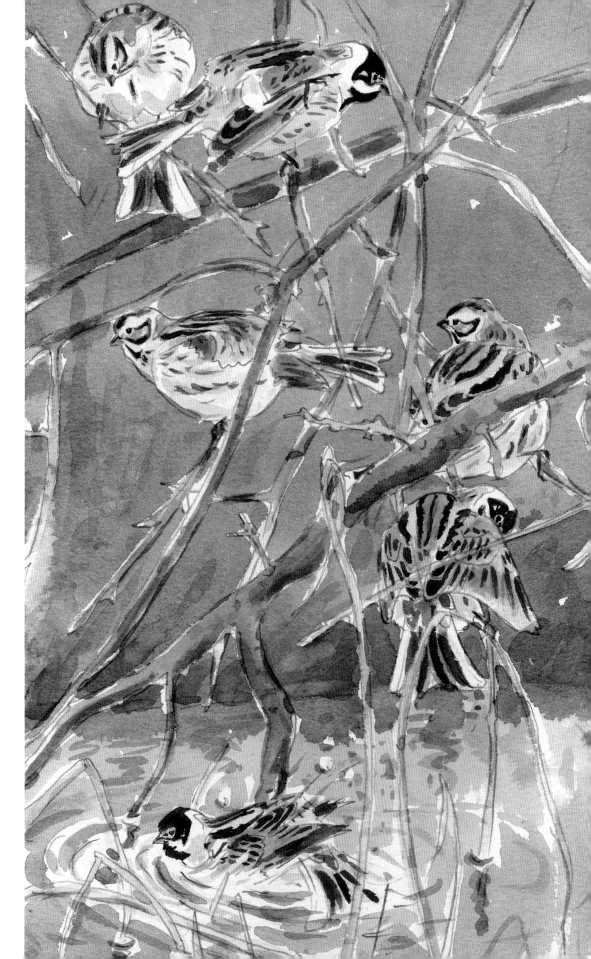

James McCallum
Reed Buntings
watercolour

'I began sketching these Reed Buntings during the first warm days of spring when several males broke away from their winter flocks to set up territories on the edge of the saltmarshes. Their behaviour fluctuated with the weather, and on cold days they re-joined the flocks again. I spent two weeks getting to know one such group as they came down to wash and preen, noting the contrast between active and resting birds. I like to combine both scientific and artistic study in a painting. For me, correct interpretation is essential before making a statement in a painting. Anything I am unsure about stays in my sketchbook until confirmed by later observation.'

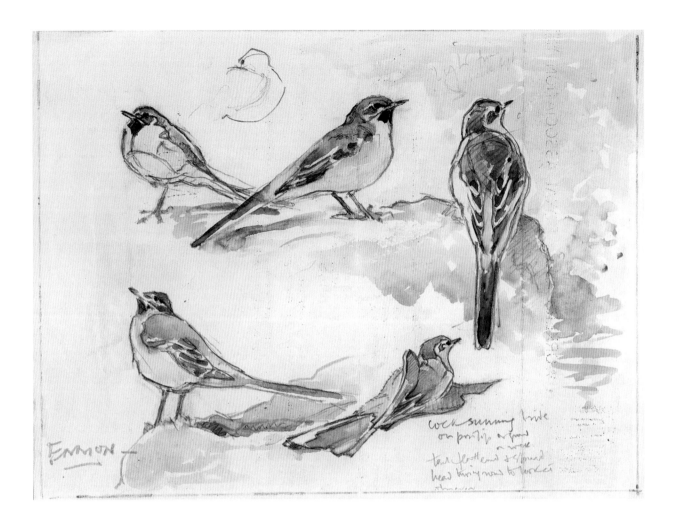

▲
Eric Ennion
Grey Wagtails
watercolour

Eric observed beauti-
fully the subtleties of a
bird's body movements,
the turn of head, the
carriage of a tail. Here
the wagtails are at rest
– one sunning itself
with half-raised wing
and spread tail.

of taking on whatever comes to you, how-
ever common. A rare bird seems to take all
one's attention, often to the exclusion of
everything else. I find it easier to be alert to
the pictorial possibilities of a scene when
watching familiar birds.

Some artists will respond more to purely
decorative aspects of the birds they are
watching, others to the sheer energy of a
scene – the play of wind and water; flight
and movement; sounds even – matching
these by the energy of marks and colours in
a more emotional response. Children's

drawings often convey such a sense of
delight, and they recognise that birds are
often funny.

I hope the enjoyment of the experience of
birdwatching shows in the drawings of all
the artists represented here. I certainly hope
mine convey a sense of the smile that is
never far away as I watch and draw.

In the book *Second Nature* [1] David
Measures says, 'The lure for the painter is the
chance of an encounter with a wild creature
that allows time enough to make a drawing.
Contained in the scribble, in that response

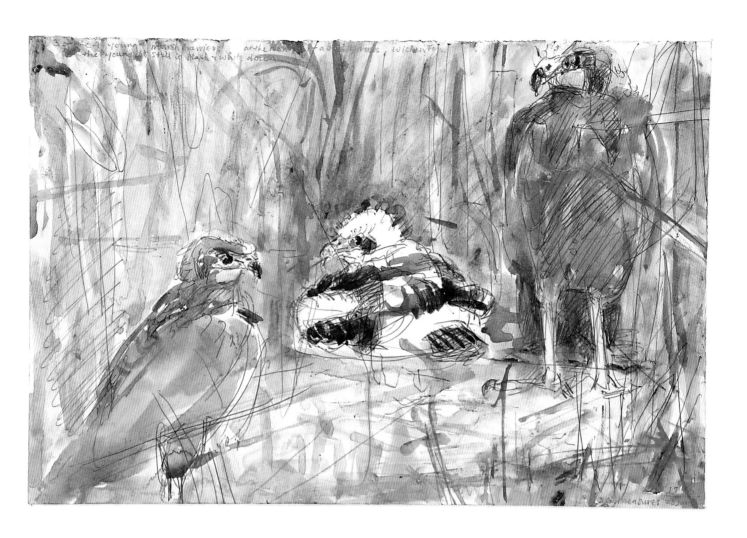

of marks and dashes, is something perhaps of the creature's vitality and elusiveness. I find the need to depict – peculiar to man – fascinating, for what a strange desire it is to re-create the intangible quality of things seen.'

▲

David Measures
Marsh Harriers
biro ink and watercolour

'*Young Marsh Harriers at their nest in the reeds, drawn from a hide at Wicken Fen. I watched in the heat of the afternoon sun as they patiently awaited a parent bringing more food.*'

1. Second Nature, *a collection of essays and images, edited by Richard Mabey, Jonathon Cape, 1984*

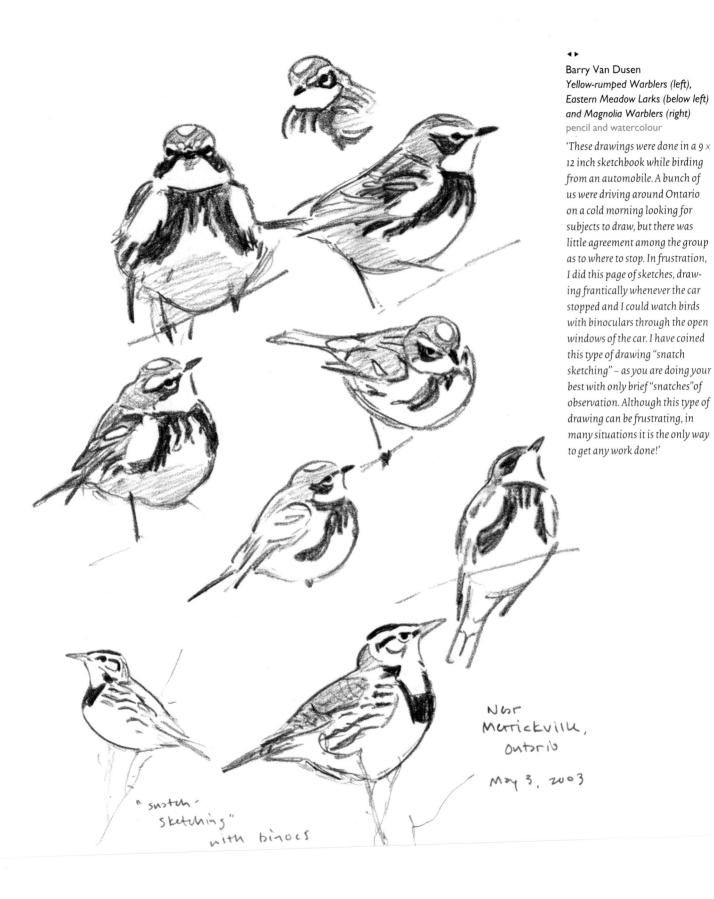

◄ ►

Barry Van Dusen
Yellow-rumped Warblers (left),
Eastern Meadow Larks (below left)
and Magnolia Warblers (right)
pencil and watercolour

*'These drawings were done in a 9 ×
12 inch sketchbook while birding
from an automobile. A bunch of
us were driving around Ontario
on a cold morning looking for
subjects to draw, but there was
little agreement among the group
as to where to stop. In frustration,
I did this page of sketches, draw-
ing frantically whenever the car
stopped and I could watch birds
with binoculars through the open
windows of the car. I have coined
this type of drawing "snatch
sketching" – as you are doing your
best with only brief "snatches"of
observation. Although this type of
drawing can be frustrating, in
many situations it is the only way
to get any work done!'*

Nor
Merrickville,
Ontario

May 3, 2003

"snatch-
sketching"
with binocs

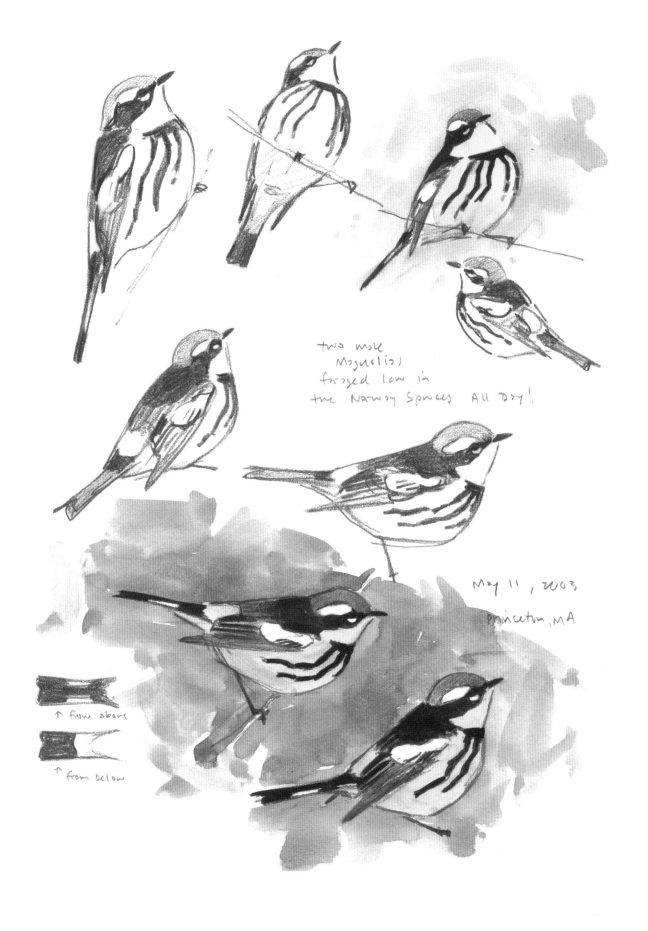

two male
Magnolia(s)
foraged low in
the Norway Spruces All Day!

May 11, 2003
Princeton, MA

↑ from above

↑ from below

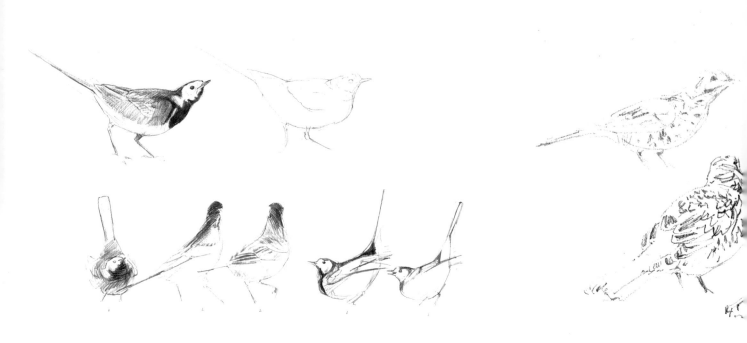

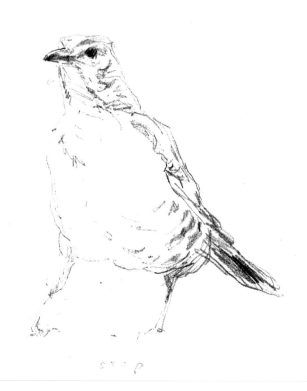

▲ ▶

Steve McQueen
Pied Wagtail and Mistle
Thrush movement studies
pencil

'Sequential drawings can help you to understand behaviour. In the Pied Wagtail sequence of a pair displaying, the tail is held vertically and the black throat displayed. Thrushes have distinctive gaits, which are well shown as they forage on open ground. Mistle Thrushes have a particularly athletic quality in their movements as befits their stature. To make purposeful drawings it helps to develop an objective eye and accurate observation. Whenever I draw I strive to make the marks work together in some way regardless of the subject.'

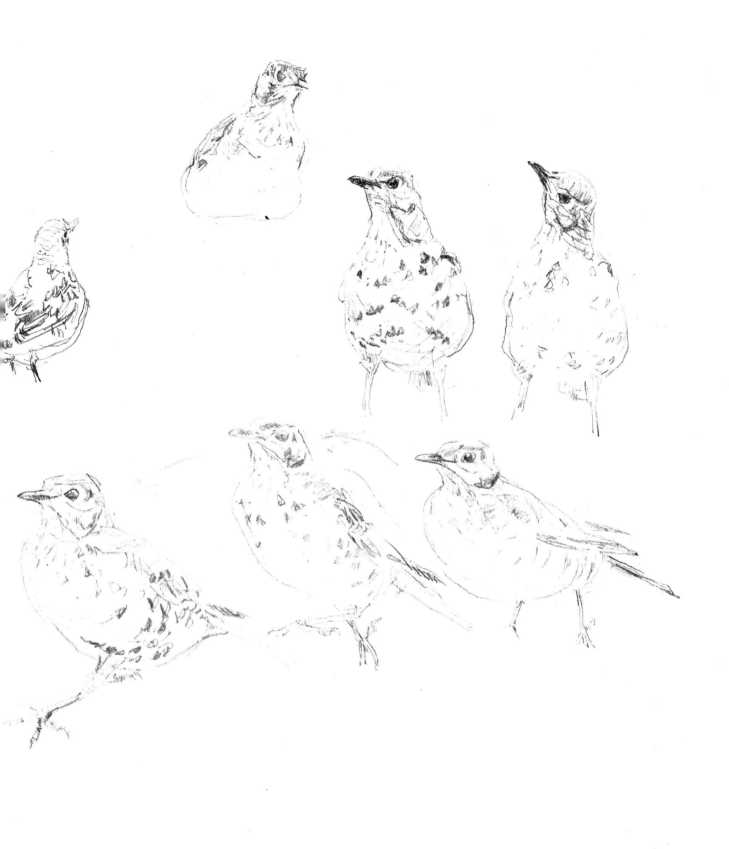

David Bennett
Studies of Blackcock
strong clear watercolour
brush drawings

Black Grouse. 'This
lekking site in Teesdale is
wonderfully situated. The
action spreads across the
valley as the black cocks
follow the dispersing grey
hens, who seem to have
little interest in the
males. The black grouse
are strikingly beautiful
close to and fascinating to
watch as they congregate
at their traditional
lekking sites.'

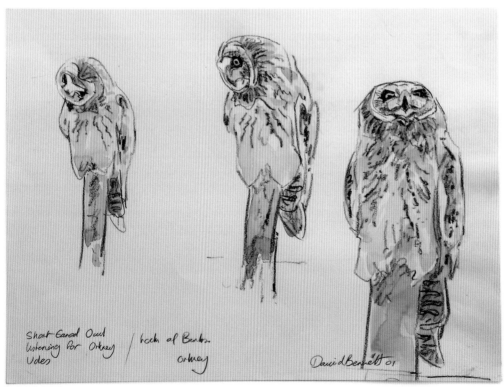

David Bennett
*Short-eared Owls looking
for Orkney Voles*
red conté and wash

Short-eared owl, Loch of
Banks, Orkney. 'Resting
and grooming on an old
fence post, the owl's head
tilts and turns with
graceful movements – an
opportunity to get to grips
with the planes and curves
which make owls such a
delight to draw.'

Denis Clavreul
Blackbirds fighting
conté crayon

These birds are locked together in battle by the dynamics of the drawing – the strong blacks coming together at the point of action. The blank space on the right adds to the dramatic movement of the birds.

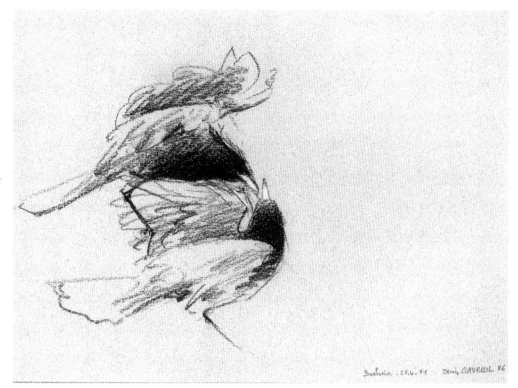

Denis Clavreul
'Spatules': Roseate Spoonbills in Florida
watercolour

Birds are seldom still, and the challenge to depict movement leaves the artist little time to absorb other things. Here Denis Clavreul, watching spoonbills sitting tight on eggs, has found time to respond to the subtle play of sunlight and shadow that transforms the whole scene and the plumage of the birds. Margin studies of other postures and details.

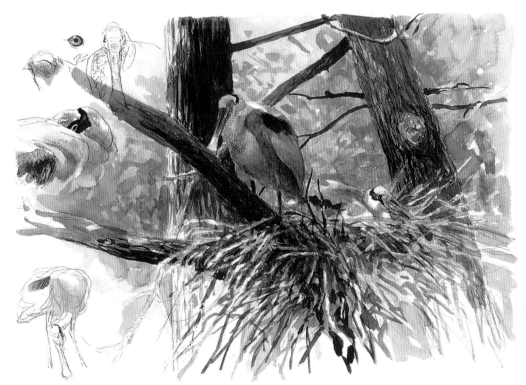

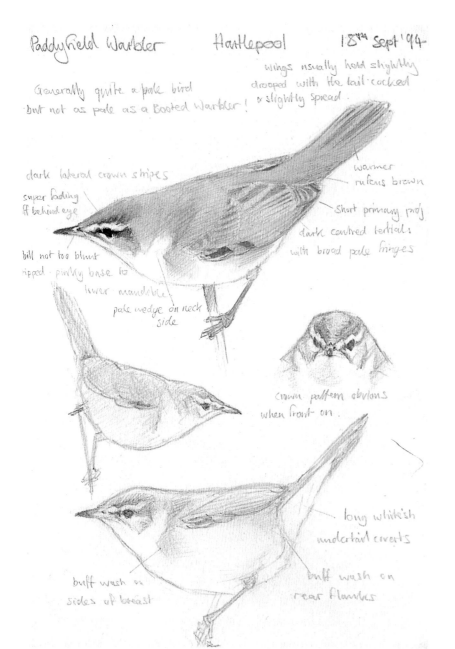

Paddyfield Warbler Hartlepool 18ᵗʰ Sept '94

Generally quite a pale bird
but not as pale as a Booted Warbler!

wings usually held slightly
drooped with the tail cocked
& slightly spread.

dark lateral crown stripes

super fading
ff behind eye

bill not too blunt
tipped · pinky base to
lower mandible

pale wedge on neck
side

warmer
rufous brown

short primary proj

dark centred tertials
with broad pale fringes

crown pattern obvious
when front on.

long whitish
undertail coverts

buff wash on
rear flanks

buff wash on
sides of breast

Ian Lewington
*Paddyfield Warbler sketch
and Illustration*
pencil and crayon / acrylic

*A rare eastern vagrant to Britain
watched for about an hour, looking
intently for 15 minutes before
sketching. Since seeing this bird I
have used my studies to produce the
illustration below for Birds of the
Indian Sub-Continent. (Published
by Smithsonian).*

Ian Lewington
Red-headed Bunting
Pencil and watercolour

*A careful study of another uncom-
mon visitor to Britain. Accuracy over
diagnostic details such as the length
of bill and folded primaries, the
extent of eye stripe and the overall
jizz of a bird is essential for identifi-
cation, and for Ian to make his fine
paintings for field guides and other
definitive books.*

♂ Red headed Bunting Walton on the Naze 31ˢᵗ May.

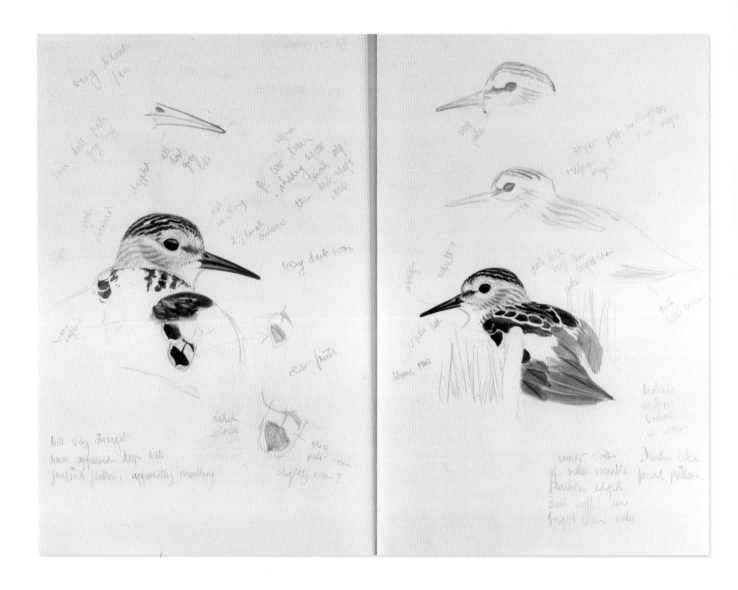

Killian Mullarney
Least Sandpipers
pencil and watercolour

A rare vagrant from North America, observed through a telescope. A cool head is needed in the excitement of watching rarities, especially when a drawing has to be the basis for proving the bird's identity. Note that blocks of feathers are drawn before they are filled in with detail. Often there is time only to do a few representative feathers in each group. Particular points to observe in the tricky business of wader identification are shape and length of bill, amount of streaking on the breast and pattern of the back, length of wing in relation to the tail and whether there is a hind toe. In flight a wing-bar or the lack of it could be diagnostic. Killian adds written notes about details.

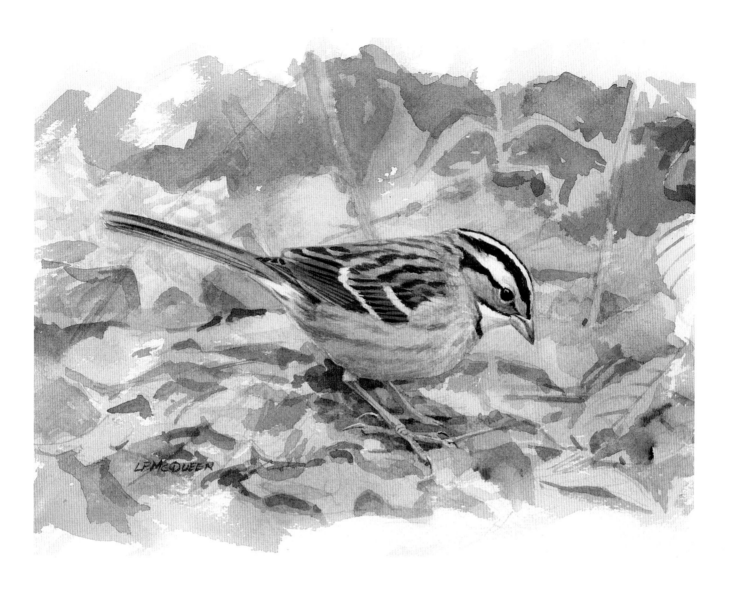

Larry McQueen
White-crowned Sparrow
watercolour

'Several white-crowns came
regularly to my feeder in
Oregon so I had a willing
subject only a few feet away. I
did not want the feeder
included, so I put the bird
among tree litter which is its
usual habitat.'

▲

Chloe Talbot Kelly
House Sparrows
pencil

House Sparrows are probably the most neglected birds in wildlife art, but, like crows, they are full of character and social interactions, and make accessible models.

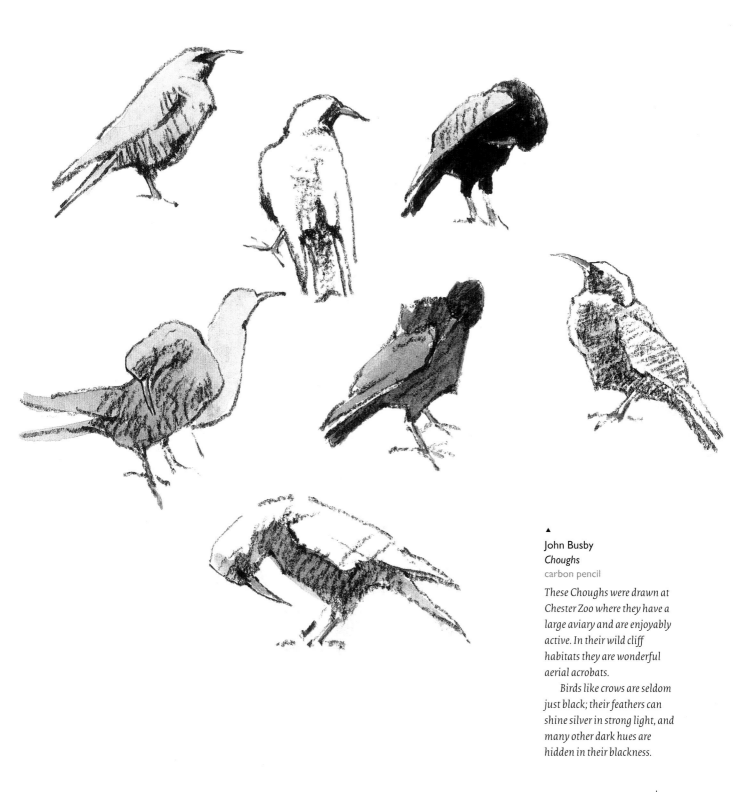

▲

John Busby
Choughs
carbon pencil

These Choughs were drawn at Chester Zoo where they have a large aviary and are enjoyably active. In their wild cliff habitats they are wonderful aerial acrobats.

Birds like crows are seldom just black; their feathers can shine silver in strong light, and many other dark hues are hidden in their blackness.

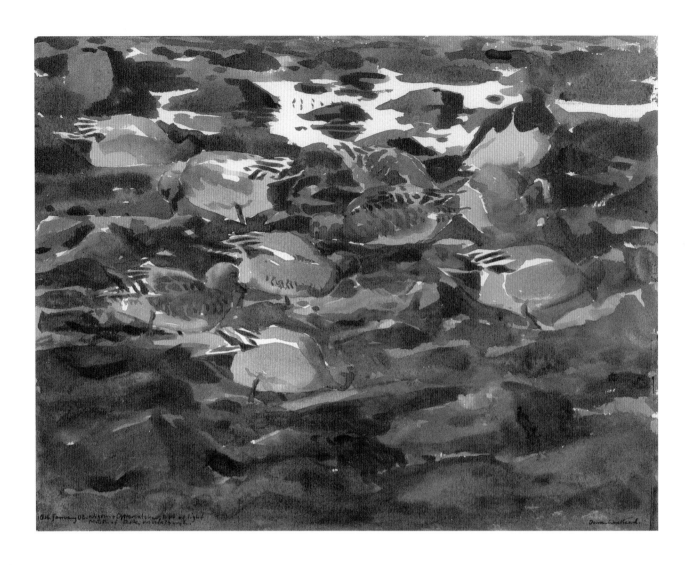

▲

Darren Woodhead
Wigeon and Oystercatchers in evening light
watercolour

'Painted at the river mouth in the last of the light, which made the dull grey wigeon glow orange. The brightest area being the pool behind, reflecting the sky. The birds soon began to merge with the background in the gathering dusk.'

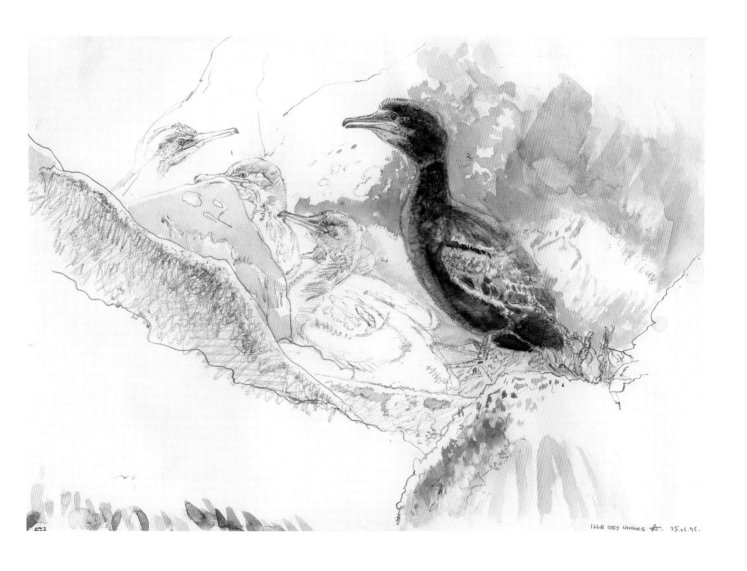

ILLE DES LANDES A. 25.06.96.

▲

Alan Johnston
Shag family
pencil and watercolour

*Painted on a visit to Ile des Landes
in Brittany when Alan was work-
ing on his book* La Baie de St.
Michel. *'The birds there are not
used to visitors so I hurried to draw
in as much as possible and fix the
image in my memory so as not to
disturb the birds.'*

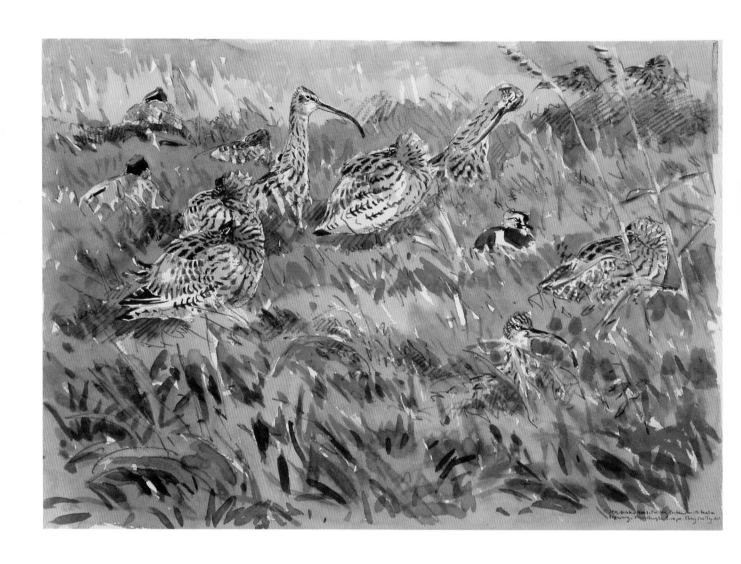

Darren Woodhead
*Curlews, Teal and Lapwings
resting at high tide*
watercolour

*'I began drawing a small group
of curlews resting in long grass
during high tide. As time passed I
saw other heads appear among
the tussocks. Time was limited
because as soon as the tide
turned, the birds would be back
among the freshly exposed
feeding grounds.'*

▶

Eric Ennion
A page of waders painted
for an unpublished book to
be called Birdman's River
watercolour

These miniature studies
are full of freshly observed
postures and qualities of
light. They are painted on
brown paper using
Chinese white and very
few colours. A Redshank
hovers jerkily over an
intruder, as they will when
young are about. The other
birds are Curlew,
Greenshank, Black-tailed
Godwit and a group of
Bar-tailed Godwits.

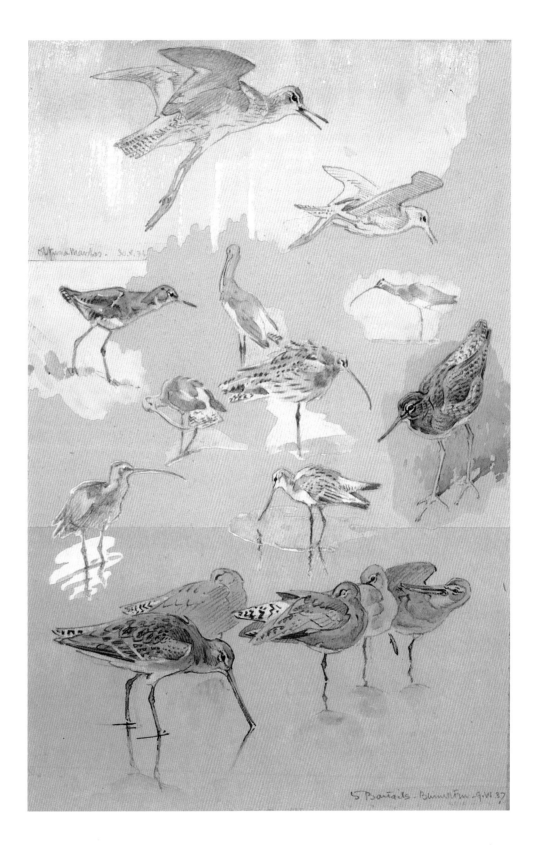

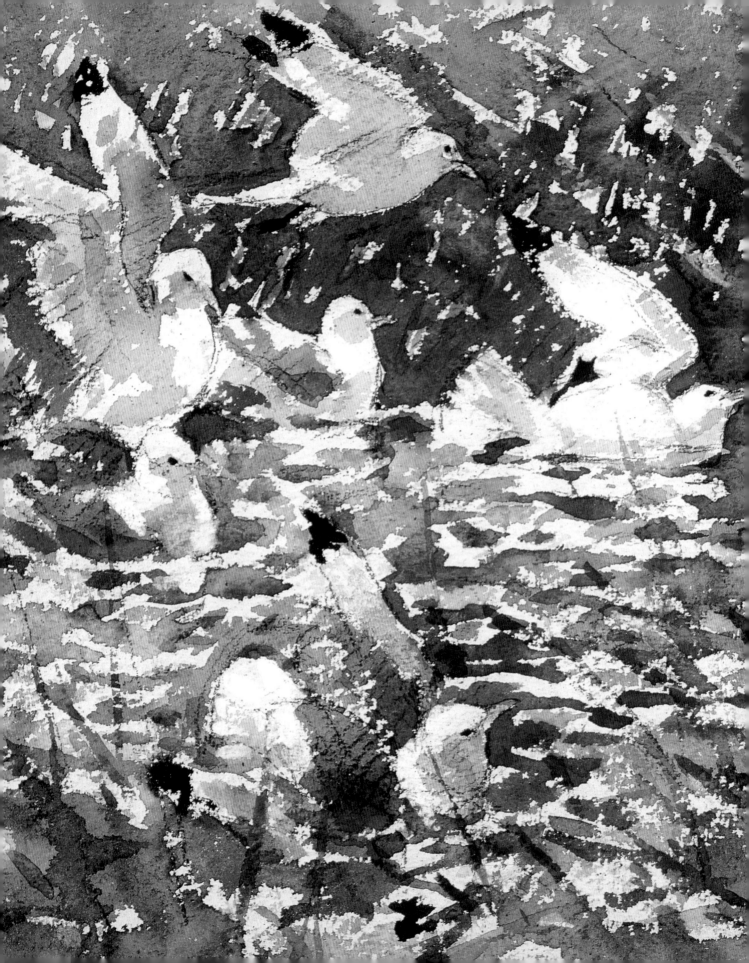

5 Birds in the Water

Many birds are as at home in water as they are in the air. Some are so highly designed for an aquatic life that they walk on land only with difficulty and may be laboured in flight (or, in the case of penguins, have completely lost the ability to fly). But put them in water and they become once more creatures of grace and beauty.

From an artist's point of view, water, being more tangible than air, envelops a bird in its own reflecting colours and shifting light. This increases the complexity and excitement of seeing. You have to take in not just the look of the bird, but all the changes that water brings about. It is an element full of surprises and magical transformations.

If you are a swimmer yourself you will know the feel of buoyancy (and the lack of it); that point of equilibrium between your weight and the support of the water. Artists often have difficulty making a swimming bird, a duck, for instance, settle buoyantly

◄
John Busby
Bathing Kittiwakes,
St Abb's Head (detail)
watercolour

Groups of gulls come from their nesting cliffs nearby to bathe in a freshwater loch. There is a great flurry of dipping, rolling and wing splashing. I drew this mostly with the brush with light quick brush strokes to allow the handmade paper to flicker points of light.

►
Alexander Campbell
Mandarin Ducks
charcoal

A beautiful expressive drawing using the charcoal's range of smudge and line to convey the form and movement of ducks and water.

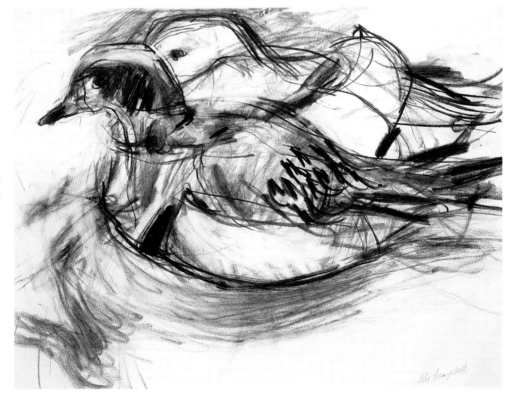

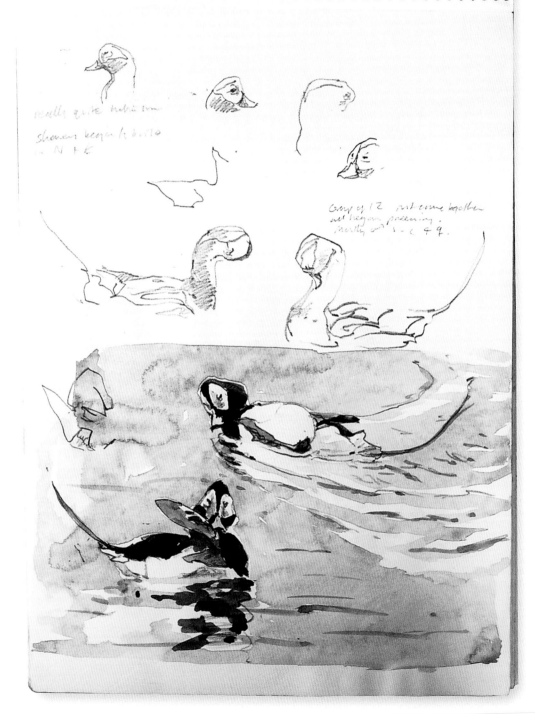

Darren Woodhead
Preening postures, Long-tailed Ducks, Firth of Forth
pencil and watercolour

*'Long-tailed ducks feeding
and preening just off the
sea wall. The stillness of
the water allowed reflec-
tions, even as a duck
pushed itself around in
circles as it preened.'*

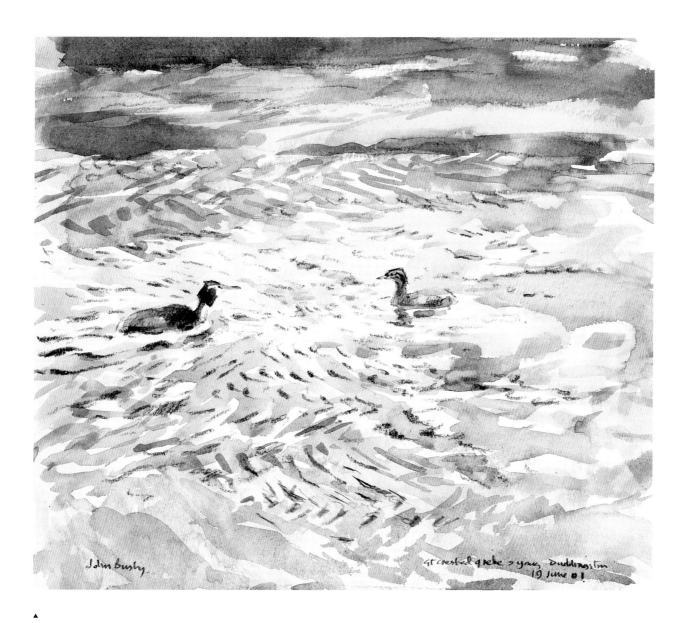

▲

John Busby
Great Crested Grebe and young
watercolour

The young grebe swims towards the parent, which is bringing food. The water of Duddingston Loch is crossed by eddies of wind and rippled light which help carry the eye across the painting.

into the surface. When the water is still and the duck is too, this is fairly simple. More often, however, there is movement of one or the other, or of both. A fast-swimming bird creates a bow-wave in front and a wake behind. Whatever the action, look how the water still hugs the form of the bird, and feel the energy needed to press against such resistance. Imagine the bird's water-line going right round its body, showing all the

curves and hollows of its form. Draw through the bird as if it were transparent and you were making a 'water-plan' of its shape. To take a straight horizontal water-line across the bird's body will just flatten the bird, so take a viewpoint above the surface and establish the plane of the water with a few directional lines. Water surfaces show many interlocking directions of movement that can lead the eye into the picture: wind

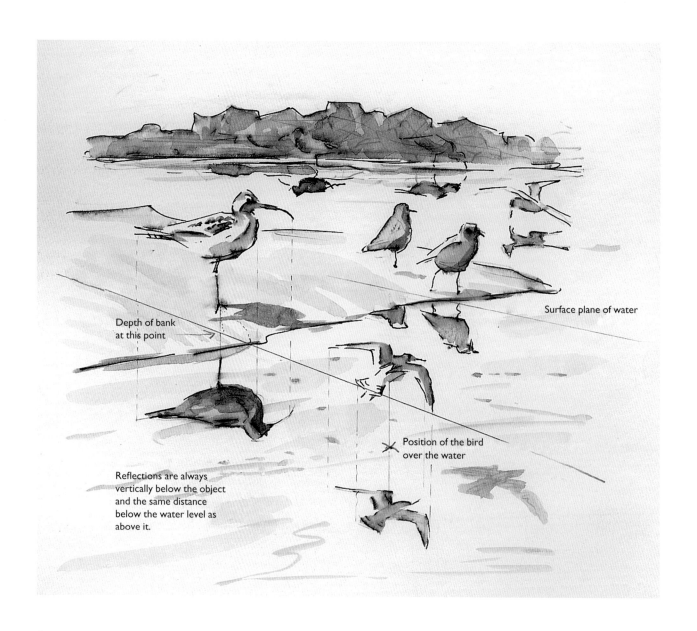

Depth of bank
at this point →

Surface plane of water

Reflections are always
vertically below the object
and the same distance
below the water level as
above it.

Position of the bird
over the water

▲

John Busby
Reflections
ink and wash

A reflection is always vertically below the object, the same distance below the water level as the object is above it, and upside down. Ripples on the water can distort the reflection and break it into

fragments which in turn can be reflected the right way up! How much you would see of a bird standing on the bank away from the water's edge, depends on the height of the bank above the water level at the position of the bird, and also on the angle of your own viewpoint.

and current patterns ruffling the surface; the ebb and flow of tides and sea waves; and changes of colour and lights and darks made by reflections.

There are a few basic optical rules relating to reflections. These are useful but can look rather artificial if applied mechanically. Reflections need the element of surprise. The first rule is that (on a flat surface), the reflection is always vertically below the image no matter at what

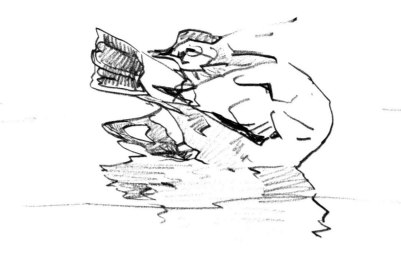

▲

Darren Woodhead
Preening Lapwing
pencil

*'A familiarity with Lapwings
after many hours drawing,
helped me to capture this
brief action. The first lines
were drawn without taking
my eyes off the bird.'*

grams). Here you have to extend the plane of the water, imagining it to continue under the river bank or whatever to a point directly below the image. Then measure the total height of the image above the water-level, projecting the reflection the same distance below. How much you would see depends on how high above the water you are yourself.

So much for theory; it is far better to observe and record what you can *actually* see, and to enjoy the unexpected. Often at the water's edge the reflection is seen sharply when the bird itself is camouflaged against the bank. Ripples can produce multiple reflections of a bird and can distort like a fairground mirror. Reflections usually reveal more of the underside of a bird, which may be lit by light off the surface. If the water is coloured, this will change the colours of the reflected bird.

angle you view it, and it will be upside down. The second is that it will be as deep below the water level as the image is above. This rule is true only on a mirror-like surface, a few ripples can change and extend a reflection. As a basic principle it applies also to objects set back from the water's edge, for instance, a tree, heron or clouds (see dia-

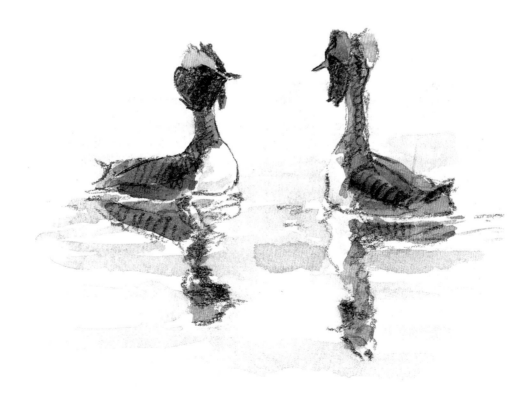

▶

John Busby
*Slavonian Grebes
courtship display,
observed at Loch Ruthven
RSPB nature reserve.*
watercolour

◄

David Measures
Dipper and waterfall
ballpoint pen and wash

A scene evoked with a few lines and delicate wash, setting the perched Dipper against the running water.

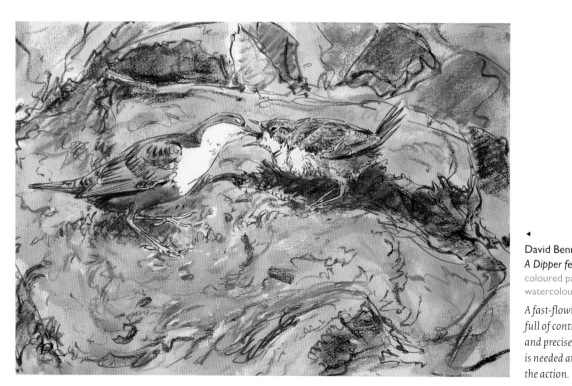

◄

David Bennett
A Dipper feeding young
coloured pastel and watercolour

A fast-flowing drawing full of contrasting energies and precise detail where it is needed at the focus of the action.

David Measures
Dipper swimming
ballpoint pen and
watercolour

'With snow on the hills and
the river in flood, a Dipper
swims out from its perch
and dives for food on the
river bed. It is completely at
home in the water, like a
river penguin!'

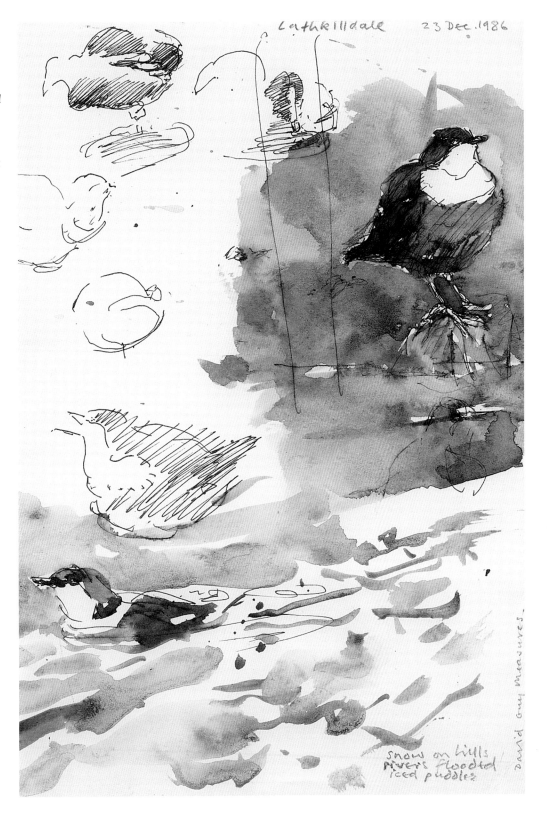

Lathkilldale 23 Dec. 1986

snow on hills
rivers flooded
iced puddles

David Guy Measures

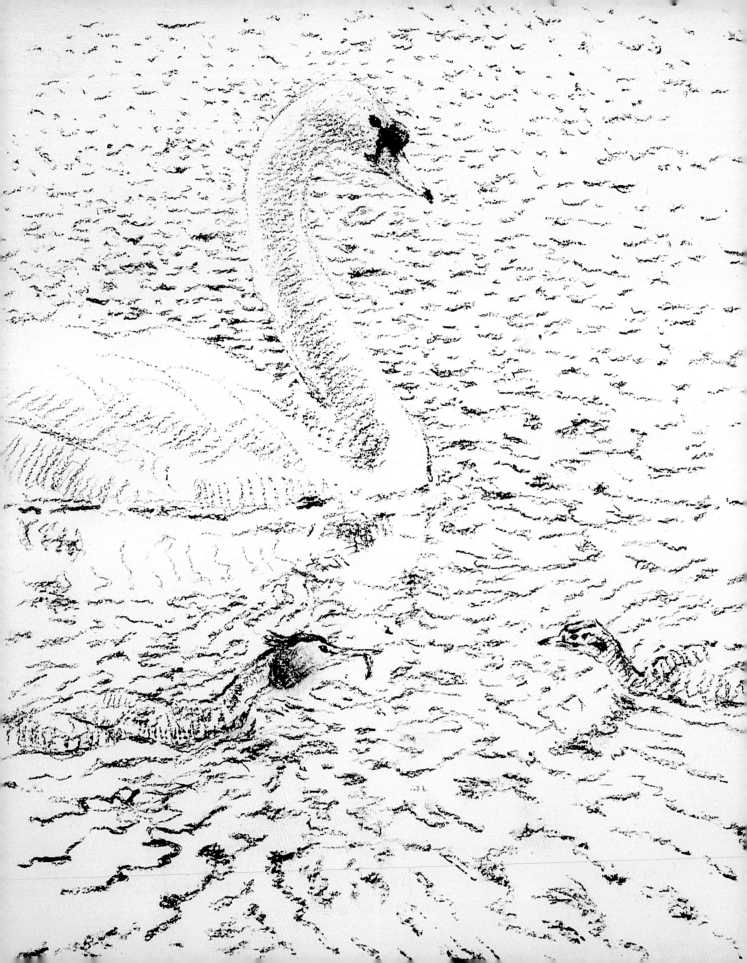

◄

John Busby
*Mute Swan and Great Crested
Grebes against shimmering water*
pencil

*An attempt to convey the
sparkle of light and reflections
by pencil alone.*

▼

John Busby
Penguins swimming
pencil

*You may be fortunate enough to
see penguins in their native
seas, but if not, many zoos have
underwater viewing windows
where you can admire their
swimming prowess or see them
from above as their forms are
often distorted by the refraction
of light. These King penguins
are from Edinburgh Zoo.*

Painting water with watercolour links an artist immediately to the subject. Look at the way Darren Woodhead paints wetness and light, laying washes of colour without preliminary drawing, allowing the brush to respond to the movement of currents. You could spend a profitable time making small studies, to get the feel of the water and simplify the values of the colours. Give each study ten minutes at the most. By then the light will probably have changed – time for another study. One could portray all the changes of an afternoon in such a series, and even forget about birds.

Fast-flowing water in streams and rivers is more easily suggested by contrast with immovable rocks or tree roots. Constant movement is bewildering to look at. Rather than attempt from the start to express all the subtleties of light and reflections you can

see, try to understand first of all the behaviour of the water. A sketch diagram using arrows to represent the direction and speed of flow will do that; strong arrows for fast currents; lighter ones for eddies. Such a diagram will probably get closer to the actual look of the river and it will give confidence to your brush strokes in a later painting and help you to respond through the actions of your hand, to the rhythms of the water.

Painting birds that are under water would add a thrilling dimension to your art. Penguins at the zoo, distorted shapes of auks seen from a cliff top, the splash and sparkle of air bubbles that follow a Gannet's dive, or perhaps a bird seen while diving yourself; are all potential subjects. The film *The Blue Planet* showed some wonderful underwater shots of diving boobies and shearwaters.

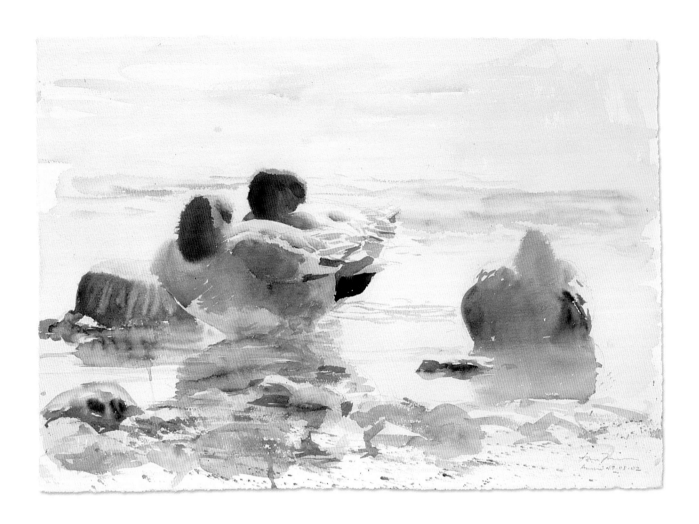

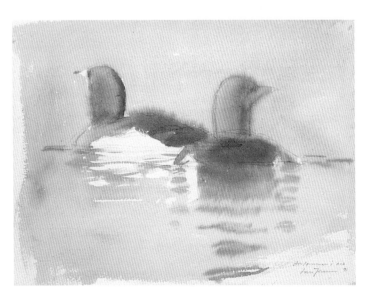

Lars Jonsson
Black-throated Divers
watercolour

The birds are seen through a telescope in hazy light where edges are diffused. It is a lovely balance of colour and tone with white as the dominant note against the soft browns and greys of birds and water.

Lars Jonsson
Sundrenched European Wigeon
'Yellow in Blue': Common Eiders
watercolour

Light is the main subject of these two paintings. The artist is seeing with the eyes of a poet as well as a naturalist. Light dissolves the shapes of the Wigeon (above) against the sea, enhancing some moments and washing out others. The Eiders (opposite, top) sit on a light-bleached rock against a colourful sea; factors which subtly change the expected colours of the birds.

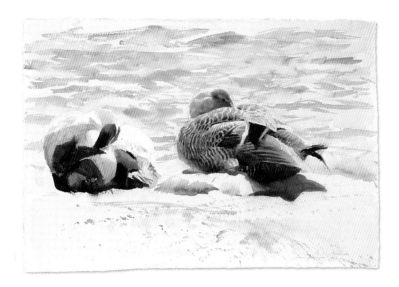

Bruce Pearson
Little Grebes under water
watercolour

'I did my sub-aqua training in the pits of old brickworks. Beneath the water lay the accumulated debris of the urban fringe – supermarket trolleys, bicycles, dumped cars and much more. Small shoals of perch sheltered in the open boot of a sunken car, pike remained motionless in the reeds, eels vanished at the first passing shadow. On one dive I caught a glimpse of a Little Grebe and saw the stream of bubbles as water pressure squeezed air from the feathers. I used sheets of coarse plastic and oil pastels to draw underwater, transferring the rough images and ideas to paper when back on shore and dry again.'

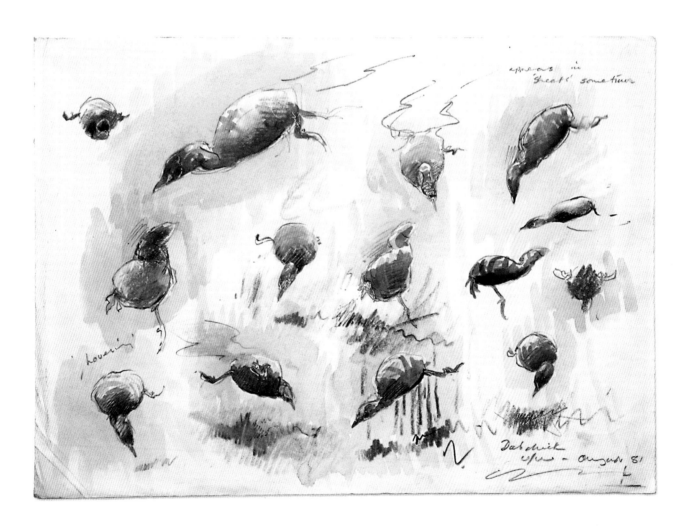

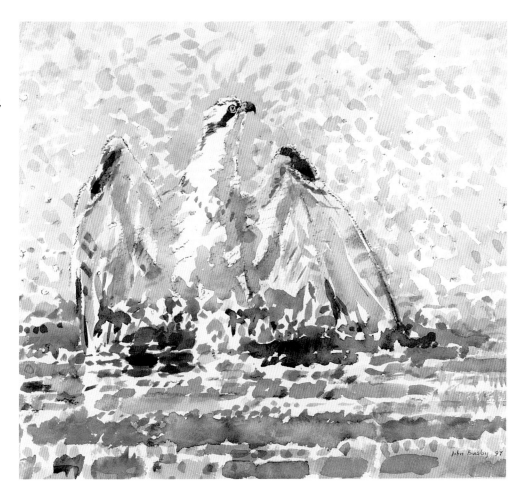

John Busby
A big splash
watercolour

Though the osprey is not a plunge diver like the Gannet, its feet-first dive sometimes creates an enormous splash that scatters a circle of droplets round the bird as it rises, phoenix-like, with a fish.

Katrina Cook
Albatross II (detail)
drypoint etching on copper

A pair of Light-mantled Albatrosses in courtship flight against a backdrop of icebergs off South Georgia. An artist's imagination is not confined to events actually seen. Katrina has not visited Antarctica but it still has a strong presence in her mind's eye. This etching in stark black ink brings out the vast loneliness of ice-filled seas.

Once, while snorkelling, I had a Brown Pelican dive a metre in front of me. It is even possible to draw under water with pencil on paper-like plastic. Pencils float, of course, so need to be tied to the wrist.

A more accessible challenge would be to draw birds bathing, dipping their heads, beating the water, rolling over, lifting off the surface for a good shake, spray going everywhere. A swan is a magnificent bather, so are groups of gulls bathing at the same time, not forgetting the Robin in a bird bath!

The sea is the ultimate water environment where even great albatrosses are dwarfed by the scale of heaving emptiness. Storms and shipwrecks are associated with the work of 19th-century romantic painters, but a few artists have experienced the exhilaration of open seas to watch birds quartering the oceans. Keith Shackleton is a painter pre-eminent among them. For the rest of us, the BBC's *The Blue Planet* films showed images of birds riding extreme conditions of wind and sea that would strike fear into a landlubber's heart.

Artists can fly the oceans in imagination and paint what they see only in dreams. Are not seabirds really the souls of lost sailors?

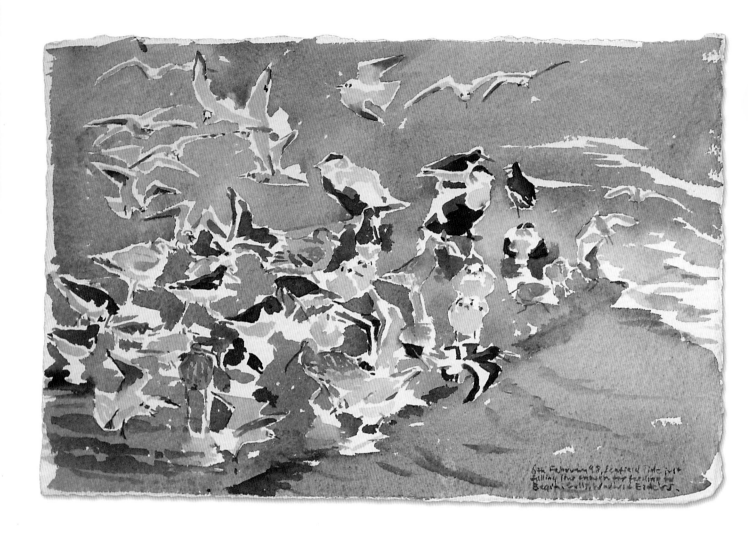

Darren Woodhead
Falling tide, Seafield, Leith

'Painted quickly as the tide fell and the birds fed voraciously. I painted the body colours first then added small details and shadows. A wash of colour was then prepared for the background water and painted on with a large fully laden brush. I painted round the shapes of the birds taking care not to touch any white areas I wanted to keep. Until this background wash is in place, I can never tell what the painting will look like. The damp conditions helped to slow down the rate of drying.'

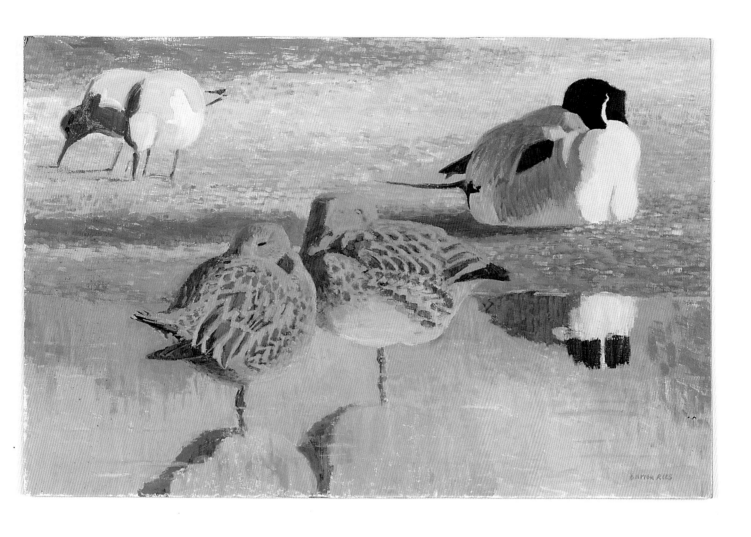

*An oil painting based on water-
colours painted from life. The
switch in medium allowed the
artist to arrange the birds in a
more considered composition in
harmony with the mood of the
original scene. There is a tightness
in the geometry of the painting
that adds the sense of stillness.*

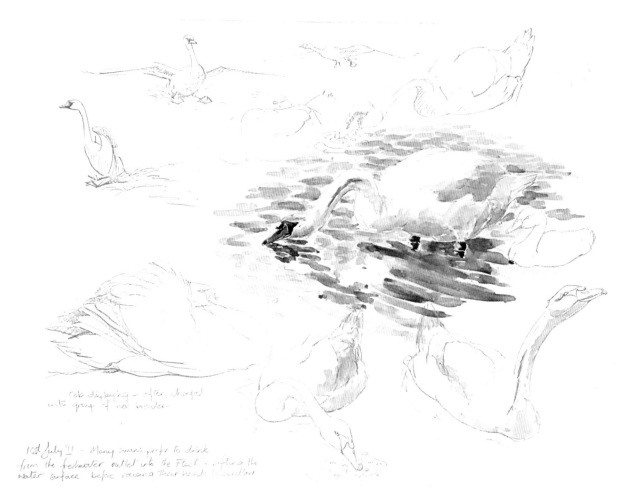

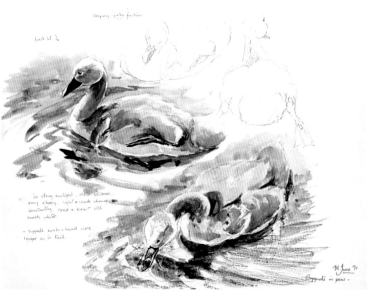

David Boys
Mute Swan drinking
pencil and watercolour
'Swans prefer to drink from fresh-water outlets into to the estuary; sifting the water surface before raising their necks to swallow. The displaying cob often charged into groups of non-breaking swans.'

David Boys
Mute Swan cygnets
pencil and watercolour

'In strong sunlight the down becomes very silvery. Light and shade changing constantly.'

▶

David Bennett
Young Shelduck and reflection
brown pastel and watercolour

▼

James McCallum
*Surfacing Red-throated Diver
startling a feeding Bar-tailed
Godwit*
watercolour

'During long periods of observation it is not uncommon to witness sudden unexpected interactions or 'one-off' situations. Some of these can be amusing and a welcome break from bouts of concentration. This event lasted only a split second before both parties and nearby gulls realised all was well and carried on feeding.'

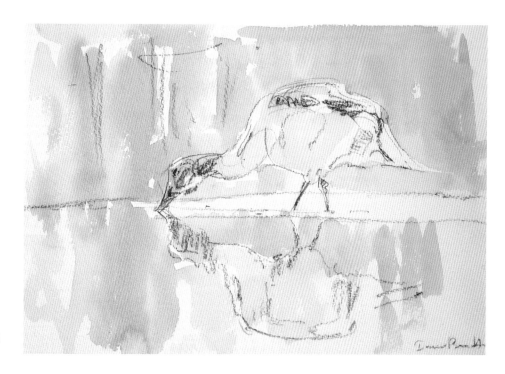

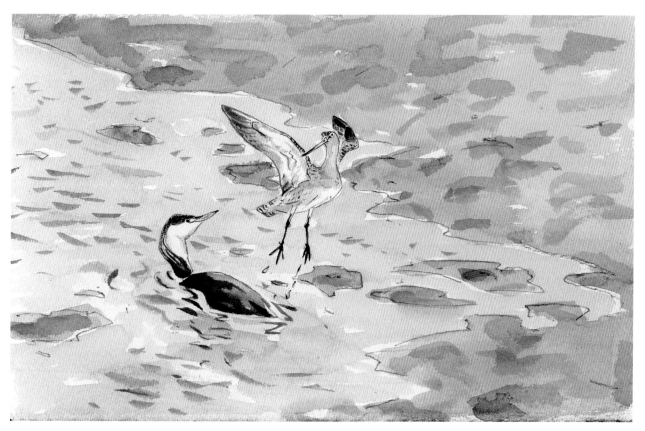

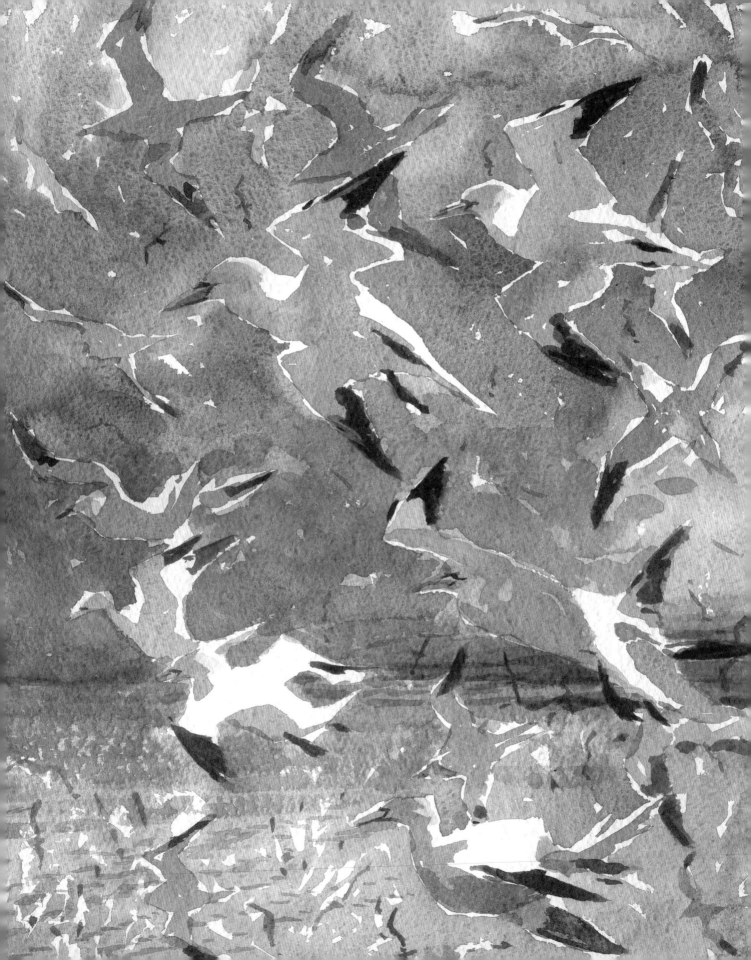

6 Birds in the Air

Darren Woodhead
Gannets over the Bass Rock
watercolour

'The thousands of noisy birds shine brilliantly white as the sun caught them against heavy clouds. Painted with a limited palette of cobalt blue, aureolin yellow, ochre, crimson and light red – the shadows of birds painted first, followed by the dark clouds which picked out the shapes of the gannets and pulled the picture together. The dark wing tips and face patterns finished the birds.'

A bird in flight, freed from the hold of earth to move into the dimensions of space, supported on invisible currents of air where it may lift above your head or sweep away below you in a twinkling, is a wonderful challenge to the artist. Can a drawing made in response, fly through the 'air' of a blank page with equal balance and freedom?

To draw flight I think one has to begin, in imagination, to sense the air as a bird's wing can feel it. When I was a boy I had a passion for making and flying model aeroplanes and kites. Perhaps this helped to instill a feeling of air in my bones. (Today, if I were years younger, I would be a hang-gliding birdman without a doubt.)

Now that modern generations can somewhat clumsily join birds in the air, it may be that flight is easier to understand than it was to artists of an earlier age. Looking back at bird art generally, even that of the first decade or two of the 20th century, there are few examples of well-drawn flying birds. Most artists kept their birds grounded. Aeroplanes have made us more flight conscious, but today we have another aid to understanding not possessed by our predecessors – photography. Developments in high-speed cameras and long-focus lenses have given us pictures of birds in hitherto unseen positions of flight. From early pioneers like Muybridge, who photographed sequences of flying eagles, owls and pigeons, to Charles Voucher, Eric Hosking, and modern wizards like Stephen Dalton and Carl R. Sams, bird photography has turned a

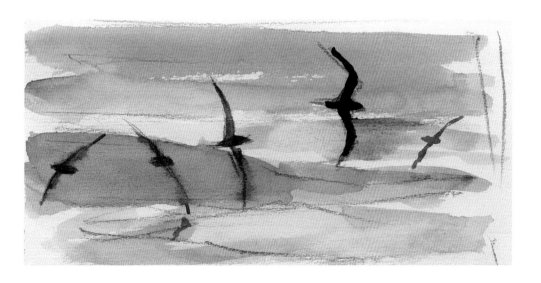

▶

John Busby
White-chinned Shearwaters
watercolour

The curve that runs through the flight of the birds, makes a nice counterpoint to that of the waves.

▲

Carl R. Sams II
Great Egrets fighting
photograph

Today's photographers have captured amazing shots of birds in action. It takes great skill and patience and a lot of luck to get a photo like this. Such pictures help artists to understand the actions of birds, and to see more clearly when they draw them in the field. Where the artist has an advantage over the photographer is that visual impressions can be retained in the memory and recreated later through drawing, although not perhaps with such striking authenticity.

blur of wings into a new poetry of action. Film sequences of flight, especially those following a bird in slow motion, are perhaps the biggest eye-openers of all. Such moments in *The Flight of the Condor* or *The Life of Birds*, and other films are memorable.

Though I rail against artists who copy photographs, I do make quick sketches from flight sequences as a film is running or soon after watching. How one wishes the editors would stay with a soaring eagle for more than 10 seconds before cutting to something else.

A still photograph's frozen moment of action may give us so much to see that if we are tempted to copy a similar degree of

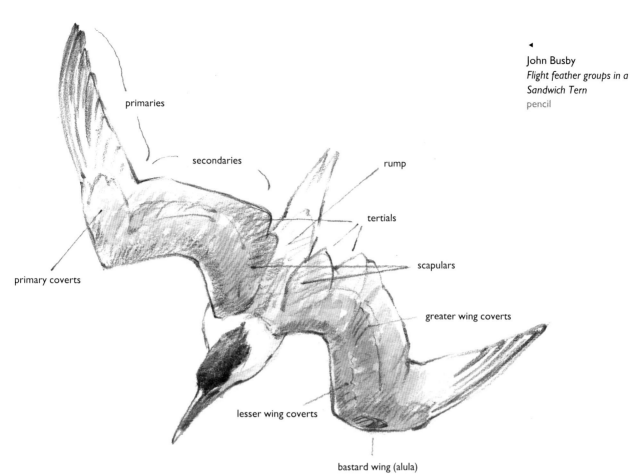

primaries

secondaries

rump

tertials

scapulars

greater wing coverts

primary coverts

lesser wing coverts

bastard wing (alula)

◄

John Busby
*Flight feather groups in a
Sandwich Tern*
pencil

detail in a picture, the result can look very
static indeed. Unless there is movement in
the drawing it may well be better to revert to
a blur of wings again. However, photogra-
phers have helped to explain wing action
and to show that a bird does not merely flap
its wings straight up and down, but that the
forward driving force springs from a figure-
of-eight movement of the 'hand' joint.

The bones of a bird's wing resemble
those of our arm. Here is an exercise that
will give you a feel for how a bird's wings
work. Try, with arms slightly flexed, a
flapping motion, leading the downstroke
with your hands (palms inclined back-
wards) letting your elbows begin the

▲

John Busby
*Wing bones in a long-winged
Gannet and a small passerine*
pencil

*The similarity to human arm
bones can be clearly seen in the
wings of a slow-flying Gannet,
but is less obvious in a small
passerine like a pipit.*

upstroke before your hands reach the bottom of the stroke. Then turn the palms forward as the hands rise, to end in a backward flick of the wrists. This is a crude imitation of the wing action of a slow, ponderous bird.

A bird cannot fly without movement of air over the wing surfaces. Either it will run or spring up to gain that initial speed or a wind current will give sufficient lift, but also the changing angles of its wing-strokes will have the same effect. It is easiest to see the mechanics of flight in action in the larger, longer-winged birds capable of leisurely movement through the air. Gulls are the commonest and usually the most convenient examples to observe, and in their wings the arm-like structure can be seen most clearly. The bones, and therefore all the adjusting mechanisms, are at the front of the wings, so it makes sense to draw both the leading edges first before the rest of the wings. Above all, watch those 'hand' joints to see how much pressure they are exerting, and the angle they give to the wing.

In gliding birds, the humerus is long. So are the radius and ulna (which do not cross as in a human arm). The fusion of what remains of hand and finger bones is comparatively short. From each of these bones comes a group of backward-facing feathers; primaries from the 'hand', secondaries from the radius and ulna, and tertiaries from the humerus. These feathers, according to their length, define the wings' width and shape. They are strong with prominent shafts and a downward curve. This aerofoil section is further shaped by the layers of smaller feathers that form the coverts on both surfaces of the wing. Because the air travelling past the wing has

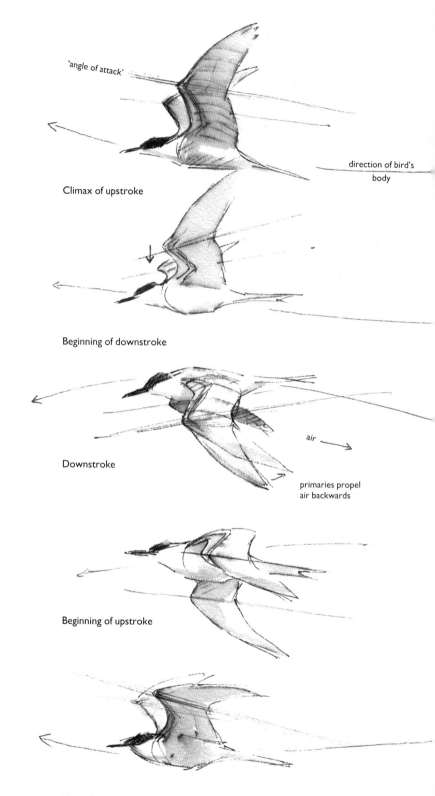

'angle of attack'

direction of bird's body

Climax of upstroke

Beginning of downstroke

Downstroke

air

primaries propel air backwards

Beginning of upstroke

Upstroke: wrists reach climax before primaries

John Busby
Sandwich Tern
wing-beat action
ballpoint pen and wash

▶

R. B. Talbot Kelly
Skua and tern
drawing and grey watercolour

The artist wrote in Birdlife and the Painter:[1] *'I have found no flying machine that compares for beauty and suggestiveness with the skuas, particularly the Arctic Skua.*

When one watches a great display of flying such as this, the wings are seen and felt as a single moving mechanism and individual feathers no longer matter. They are like flexible scythe blades that not only cut the air but also hold it.'

Talbot Kelly greatly ad-mired the economy of line in Japanese prints and in his refined line drawings he kept colour to a minimum, allowing it more expressive range in the freer brush paintings.

further to go along the curved upper surface in the same time, it has to travel faster; hence a reduction of pressure on top of the wing lifting the bird.

The primaries provide the driving power, pushing the air downwards and backwards. The vanes of the feathers are pressed firmly against the strong, flexible shafts of the preceding feathers, but allow air to slip through on the up-beat. The secondaries act as the main planing area, moving less than the wing-tips, maintaining level flight. The tertiaries extend this area and help to streamline the junction of wings and body. In small birds these last feathers are almost non-existent, the whole wing becoming the driving force with both primaries and secondaries longer than the much smaller wing bones. Instead of gliding, a small bird will missile itself through the air after a burst of power, wings closed, giving the characteristic undulating flight of many passerines.

Italian Renaissance artists often portrayed flying birds in the closed-wings position.

Though the 'hand' is reduced to three bones, the thumb still articulates and operates three feathers, known as the alula, or bastard wing. This is extended to help control air flow when a bird is landing and near to stalling, or when a bird like a falcon is flying at speed with almost furled wings. On the leading edge of the wing is a membrane containing tendons called the anterior patagium, stretching between the shoulder and the wrist, which gives the streamlined front edge to the wings; the elbow joints lie behind. (There is a similar membrane between elbow and body, but this is hidden by feathers.)

Covert feathers often show a distinct change of plumage pattern along their margins – a striking feature in some waders and ducks – so a line of the coverts can be drawn without counting individual feath-

▼

John Busby
*Foreshortening of
wings and angles*
*A simple aid to seeing wing
shapes can be cut from a
folded sheet of paper;
wings bent at the joints,
and the model held up at
various angles and in
different light conditions.*

Hold tight togther and cut out bird

cut away

cut away

fold

do not cut

fold

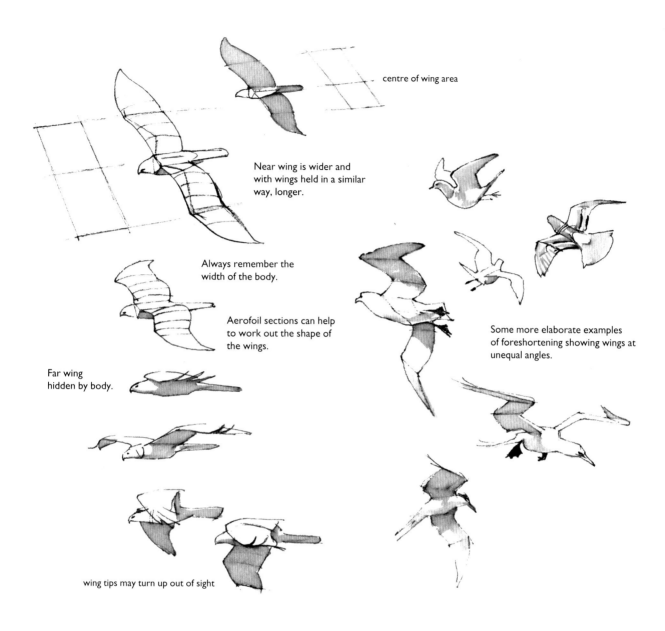

centre of wing area

Near wing is wider and with wings held in a similar way, longer.

Always remember the width of the body.

Aerofoil sections can help to work out the shape of the wings.

Far wing hidden by body.

Some more elaborate examples of foreshortening showing wings at unequal angles.

wing tips may turn up out of sight

ers. I have always found R. B. Talbot Kelly's simplification of wing feather masses helpful to follow. He treated each group as a unit, with a line that did not stop the flow of movement.

Apart from the first four or five primaries which may well be 'fingered' at their tips, the trailing edge of the wing quickly dissolves individual feathers into the general shape.

More subtle aspects of the planes and movements of the wings can be shown better by drawings than by written descriptions, and some of these will be revealed on later pages.

A flying bird invariably presents problems of foreshortening; both the body and wings may be set at an angle to you. On land, a side-view bird is the easiest to draw, but wings coming towards you or partly hidden by the

▲

John Busby
More examples of foreshortening of wings and angles
pen and wash

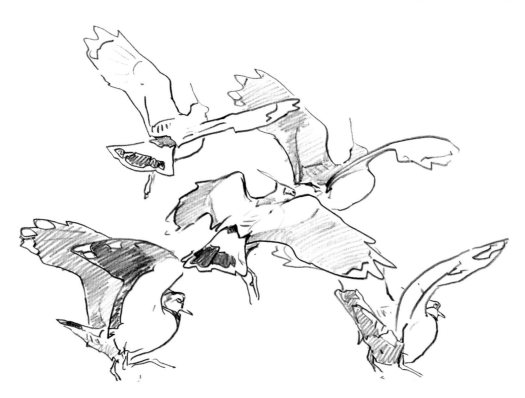

◄

Darren Woodhead
Lapwings landing & taking off
pencil

'These edgy Lapwings were constantly taking off and landing in a strong wind, their wings held in position a split-second longer than usual.'

▼

David Bennett
Bar-tailed Godwits taking off
pencil and watercolour

The whirr of wings is as confusing to human eyes as it would be to a predator. The artist's solution is to scatter marks that move across the page in a similar way, with just enough clues as to identity.

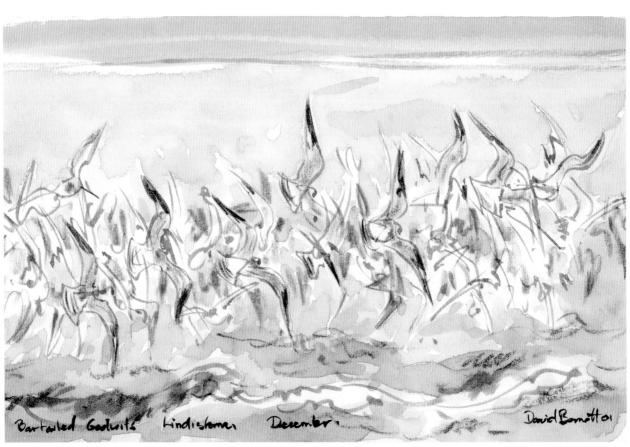

body of a flying bird are difficult to draw on the two-dimensional surface of the paper. A simple model cut out of folded paper can provide some of the answers to problems, and one can see clearly the consequences of wing angles, putting a paper bird through the wing-beat positions and looking at it from all angles.

Of course, the two wings of a bird are rarely identical in trim. Once airborne, every inch of a bird is in a state of constant adjustment to maintain momentum and equilibrium. As adjustments are made to air pressures and changes of direction, the wing shapes and angles will change, together with the shape and angle of the tail. Head and feet movements come into operation too, as the bird adjusts its weight to shift the centre of gravity – forward to increase speed, or backwards to gain more lift. Birds do not always have an easy time in the air. When the wind is strong, flying can be hazardous. On a sea-cliff one can marvel at the delicate buoyancy of Kittiwakes wheeling in all the cross-currents of a buffeting wind, or hanging on drawn tight wings, head pulled back and legs dangling. I find it helps me to draw a line representing the supporting plane of air on which the bird hangs. It can help to put imaginary section lines across the wings to make sure of their camber. (This must be a throwback to my aero-modelling days.)

To draw first a bird's flight-path can help

Charles Tunnicliffe
Black-tailed Godwits
watercolour

One of the small compositional sketches the artist made prior to a finished picture. Individual birds are merged into the overall pattern of wing movement.

▼

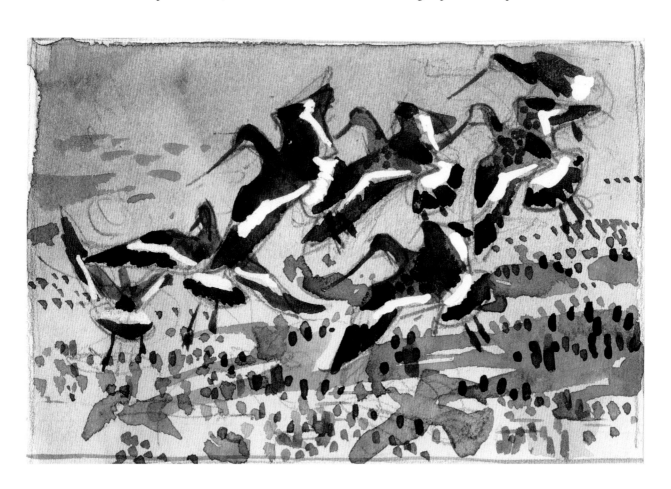

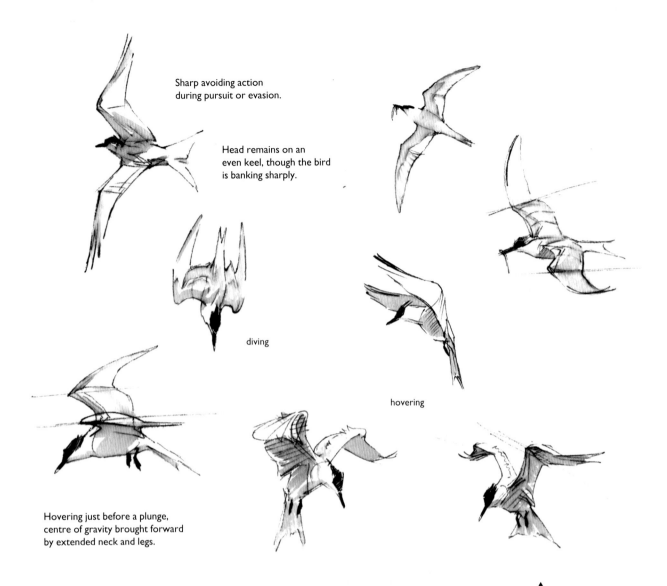

Sharp avoiding action during pursuit or evasion.

Head remains on an even keel, though the bird is banking sharply.

diving

hovering

Hovering just before a plunge, centre of gravity brought forward by extended neck and legs.

John Busby
Angles of attack in terns
Ink and wash

you to plot the changing positions of a circling gull, for instance. Drawing flight positions in sequence is one of the best ways of understanding and seeing the changes and adjustments taking place. Fast, powerful flight presents a great deal of bewildering movement, often too quick for the eye to follow, and difficult to reconstruct afterwards. It is probably best to respond to a gut feeling for the action. Pursuit, evasion and display will involve more than one bird and, curiously, it can be easier to convey action with two birds rather than one as the space

between them can increase the tension. Sharp, angular lines will show the extremes of wing action and the stress of the bird. Changes of direction, indicated by a shift of angle between head and body or tail, will add to the drama and help to point the eye across the spaces in the drawing.

Drawing flocks of birds in flight offers the dynamics of repeated pattern, especially the tight formations of flighting waders or ducks. These birds tend to fly in unison, the whole flock turning at the same time, and the V shapes of such birds add to the sense

▶

Lars Jonsson
Red Kites soaring
watercolour

Kites have a distinctive and very buoyant flight; wings angled forwards much of the time. They use their tails a great deal to control direction when the wings are held outstretched for soaring.

▼

David Bennett
Red Kites in active manoeuvre
pencil and watercolour

When it comes to faster action it is the wings that control changes in direction, varying the 'angles of attack' and the driving force of each wing.

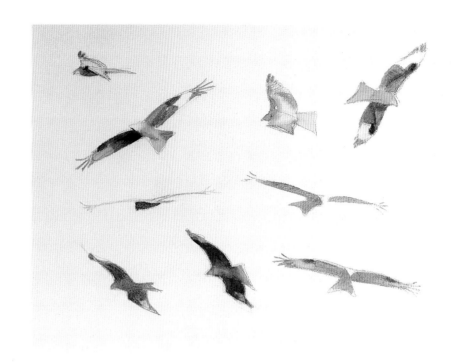

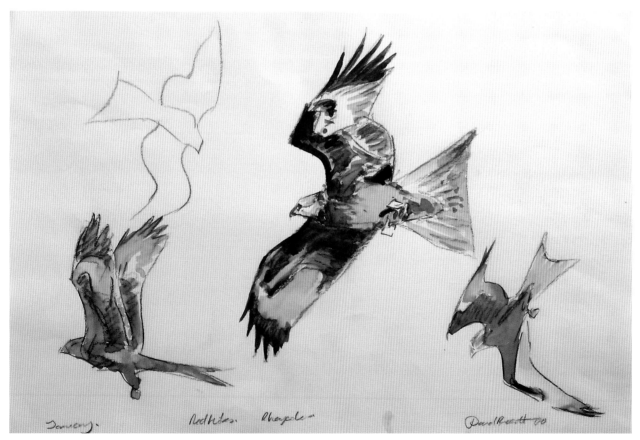

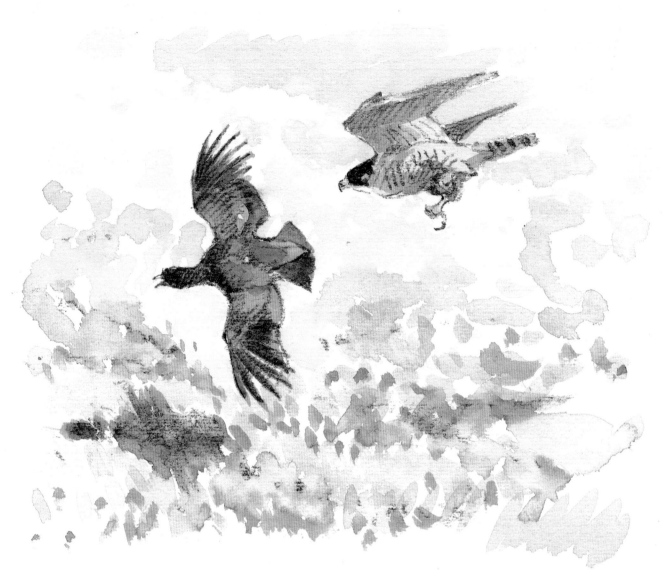

of movement. Less co-ordinated groups of flying birds can be difficult to compose well in a drawing as they are all probably moving in different planes and different directions. One needs a strong sense of the 'space' of one's flat page.

With practice and field experience, a feel for bird-flight will develop. You will need to rely on memory to a greater extent than before, and as in all bird drawing, if you can remember what the bird or birds were doing (the nature and purpose of their flight), then recalling what you saw is easier. The more

you practise drawing from memory, the more you will find stored there – providing of course that you put in those essential and enjoyable hours of watching and wondering.

Drawing is the next best thing to flying. Sometimes the drawing crash-lands before it is truly airborne. But sometimes a drawing soars.

1. Bird Life and the Painter, *R. B. Talbot Kelly, Studio, 1955*.
2. Wild Horses, *poems by Kenneth Steven, St Andrew Press, 2002*.

▲
John Busby
A falconer's Peregrine stooping at a Red Grouse
pencil and watercolour

Drawn from memory after the events of the day. To create movement, there has to be a flowing relationship between the angles and lines of the drawing. The cast shadow in front of the grouse shows its closeness to the ground, but also completes a V shape between the bird and the land, leading the eye in that direction.

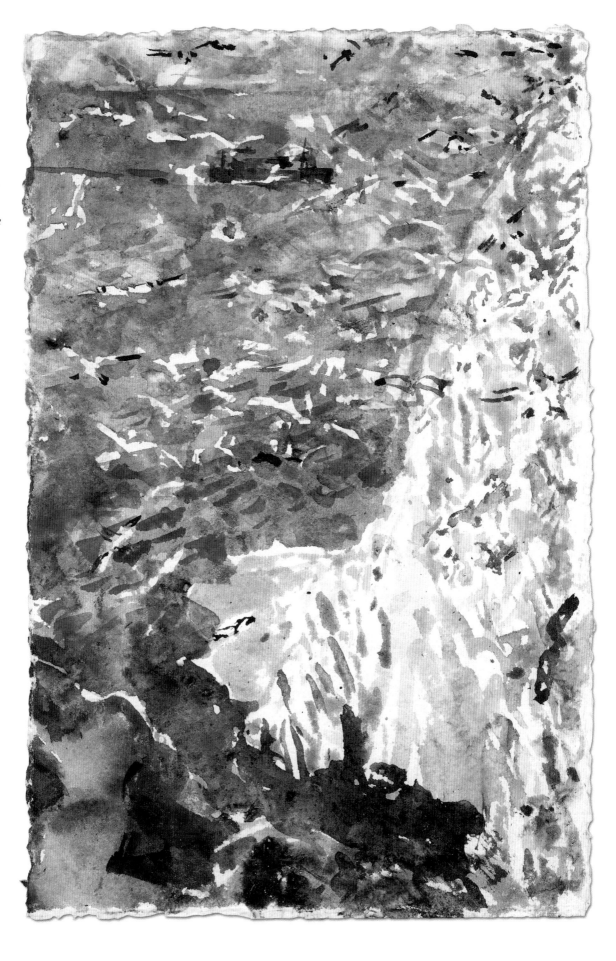

David Measures
The Bass Rock
watercolour

A celebration of all that makes a seabird colony – the colour, sounds, the movement of thousands of birds, waves, wind, space – painted on the spot with all the artist's fine-tuned intuition.

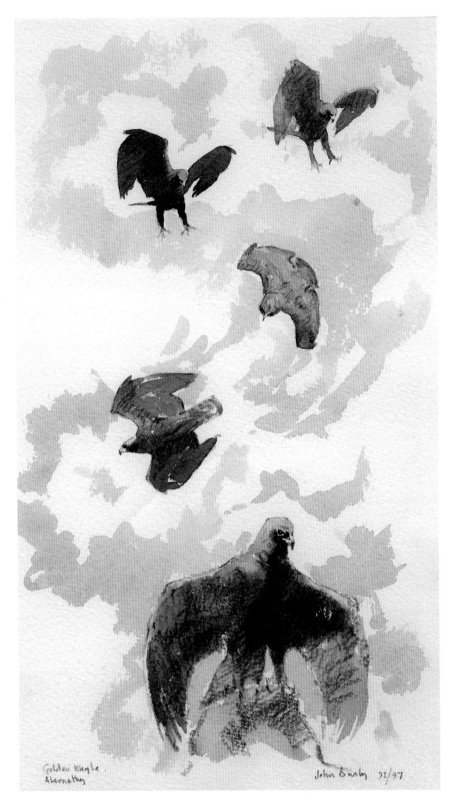

▶

John Busby
Pinkfeet dropping to land
pencil

An illustration from Wild Horses.[2] Geese breaking their disciplined formations and peeling off in a wonderful display of abandonment through the last few metres of air. The poet writes:

'The Iceland summer, the long light,
Has run like rivers through their wings,
Strengthened the sinews of their flight
Over the whole ocean, till at last they circle,
Straggle down on the chosen runway of their field.'

◀

John Busby
Golden Eagle landing
Pencil and watercolour

Studies of an eagle in Harris, Outer Hebrides, hanging in the air before half closing wings and dropping down to land. Re-drawn from quick sketches and composed, like the geese opposite, to emphasise movement.

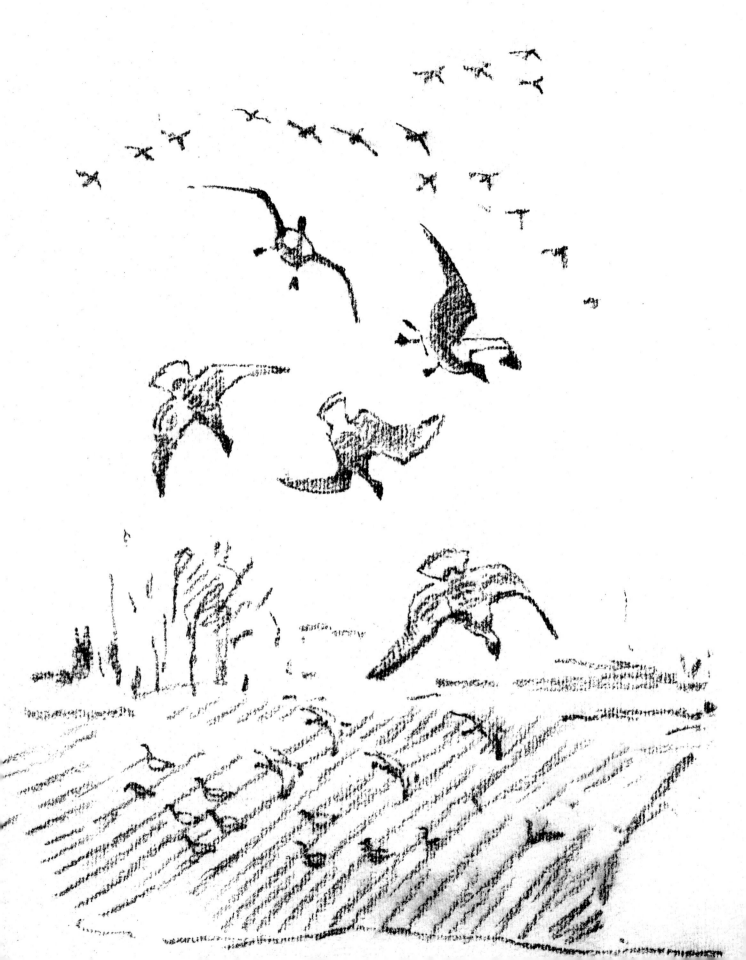

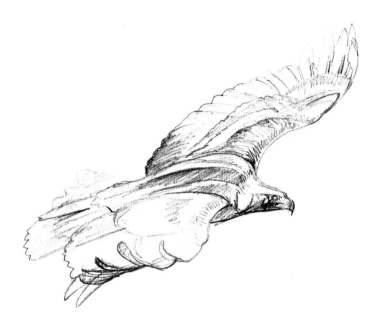

Keith Brockie
Golden Eagle
pencil

Keith is a man of the
mountains and no stranger
to Golden Eagles. A close
encounter with an eagle at
eye level is awe-inspiring
and difficult to draw
without a lot of intimate
knowledge of the bird and
how it flies. Note the bent
primaries which control the
air flow over the wing-tips

Janet Melrose
Gannets over the Bass Rock
felt-tipped pen

With the movement of
thousands of birds over-
head, one drawing response
is not to focus on one bird at
a time, but to look 'open-
eyed', letting the pen fill the
sky with bird-like lines.
Here the movement is
enhanced by contrast with
the horizontal sea and birds
on the rocks.

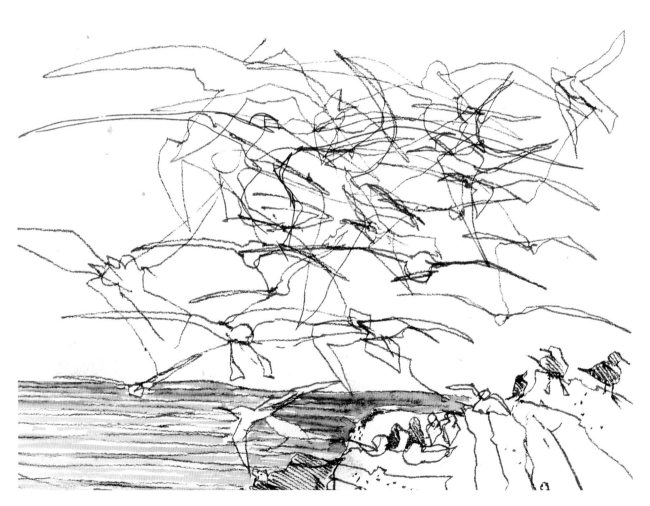

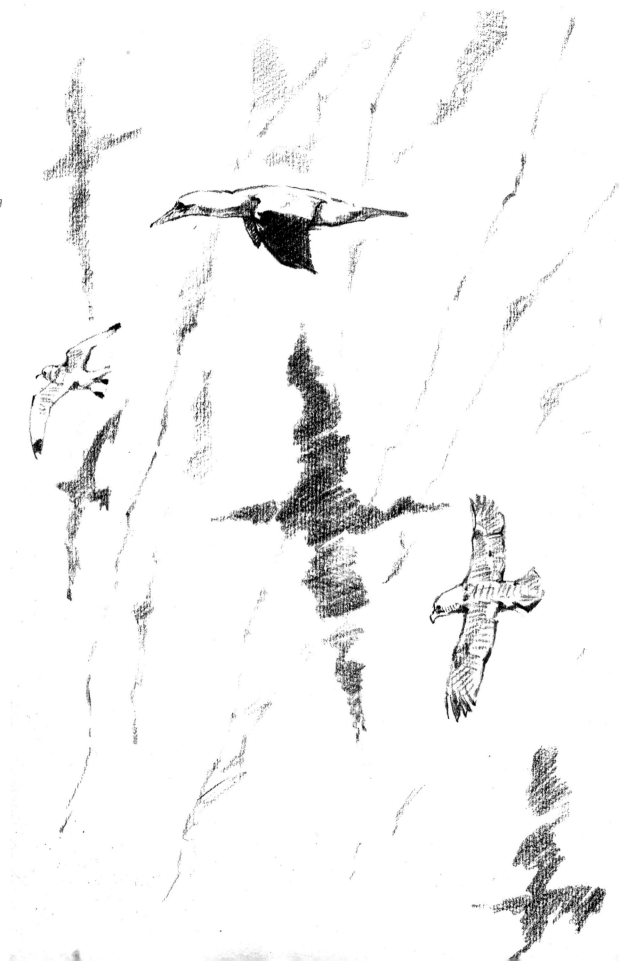

John Busby
Gannet, Kittiwake and Fulmar
conté pencil

A Gannet flying smoothly past the vertical face of the Bass Rock, its shadow keeping pace, but in an erratic frenzy across the rock. Compositionally the Gannet is poised above the point of the shadow, and all the other angles emphasise its steady level flight. The shadows of the Kittiwake and Fulmar emphasise their own distinctive movement.

7 Birds on the Page

◄

Eric Ennion
Compositional sketch for Moorhens at the nest
pencil and watercolour

Eric has divided the page into thirds, with most of the action in the top part. The focus comes where the diagonal meets the junction of vertical and horizontal. Eric blocks in the main lights and darks and adds dynamic lines and notes about colour. Interestingly, he changes his mind about the feeding bird's legs to give more movement. As the drawing progresses, Eric is able to re-live the moment and these compositional thoughts help the artist to bring the events to life.

▶

Charles Tunnicliffe
Mute Swans
watercolour and ink

Sketch for a later painting. 'Swans rocking in the waves. Fine neck curves, one behind the other', writes the artist. The painting has it all.

In earlier chapters, I suggested that there can be far more to portraying a bird than getting it feather-perfect. I encouraged you to see birds in the context of their surroundings, and to be aware of their movements and the space around them. If, in your field sketches you regularly include features in a bird's environment, then you have already begun to think about how everything relates to each other – composition in other words.

Now, what can be done through composition to communicate your thoughts about the events you see? Composition is a matter of controlling expressively all the elements in your picture. The *same* birds, trees and sky transposed into the shapes, lines and colours of your picture can be composed in many *different* ways. According to where a bird is placed within the shape of your picture, you can often say more about its ways than you can by the degree of finish. Perhaps binoculars encourage us to centre a bird in our vision, and if the aim is to make the bird a static object of scrutiny, then by all means place it right in the middle of a picture, where it will remain immovable.

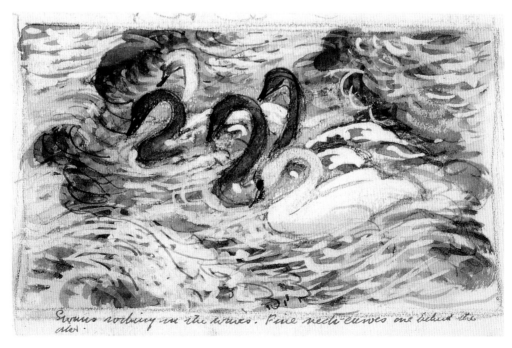

Swans rocking in the waves. Fine neck-curves one behind the other.

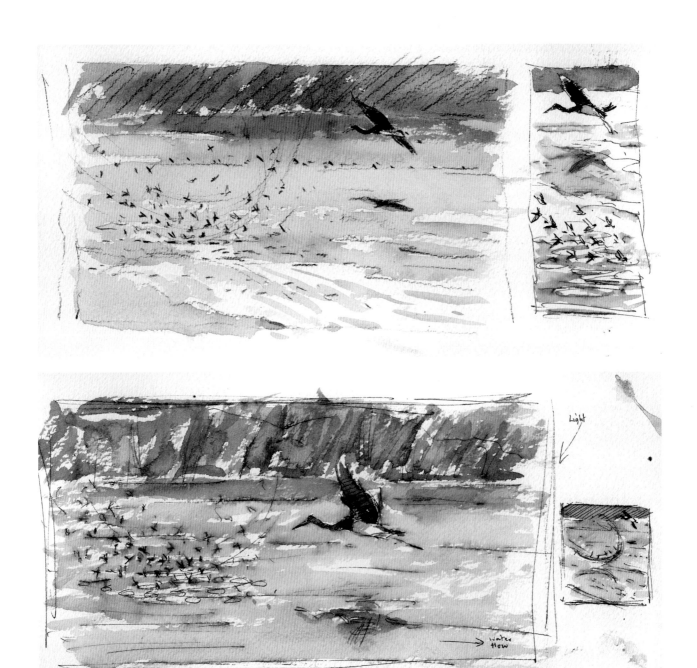

An event in Bulgaria, May 03 · Solve the equation.

▲

John Busby
Sketch ideas for an event seen in Bulgaria
watercolour

The equation to solve is: fifty or more House Martins flying round in a big circle and dipping into the river; a Black Stork flies slowly past reflected in the water; the far bank of red sandstone is also reflected in the water which flows quickly from left to right. Plenty of contrasts of movement and colour. Here are some possible solutions, there are many more.

Usually a bird's presence is unexpected and fleeting. It is seen in a sequence of movements, possibly merging with the shapes and patterns of branches or the forms of rocks, among shadows and a variety of background colours that change its appearance.

When sketching, set the scale of your bird quickly against any adjacent land-marks, trees or ground patterns before it has time to fly away. This can be done with a few simplified lines, as I suggested in Chapter 2. Detailed study can follow after the bird has flown. There is then time at leisure to make drawings of as much of the environment as you need, remembering the bird's 'track' through what you are drawing. Concocted backgrounds round a finished bird are seldom convincing – they contain none of the surprises one sees in life; so forget the conventions of 'Bird Art', and link your bird strongly to time and place and to the way a bird itself uses its surroundings. Search out the kind of placing that will convey the experience of what you saw. Moments that are brief or surprising will need to be conveyed by less predictable composing on

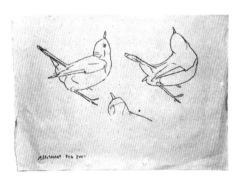

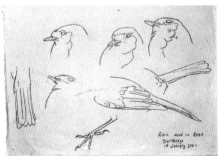

◀ ▼

John Walters
Robins
watercolour with Chinese white on grey paper

'A pair of Robins was holding territory by my allotment. Frequently other Robins, looking for mate or territory, came into the area. This led to a lot of displaying by the resident birds, showing off their red breasts to maximum effect. At the time I found a freshly dead Robin and made several drawings. These helped enormously when drawing quickly from life'. The placing of the birds in the painting conveys the tension between them very well.

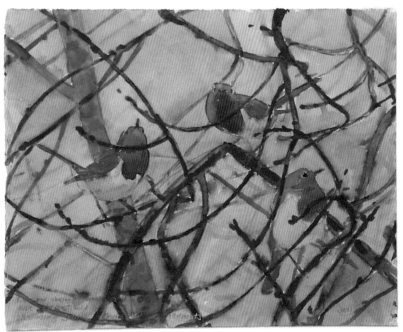

your page. The birds in your pictures should move into their surroundings naturally. Let a bird be well hidden if that is right for the occasion, without spotlighting it or fading away 'mere' background. How often do you see a sitting Woodcock or a sleeping owl so immediately as many a 'portrait' would suggest? It would make more sense to draw the eye away from a hiding bird by stronger emphasis on other parts of the scene. Background details offer as much variety of drawable material to enjoy as do the birds themselves.

It is important to remember that whatever you are drawing, you are also forming the shapes outside your lines. For instance, on the two-dimensional page, part of a sky (what one can call a 'negative' space) becomes as much a shape as a solid object – a bird or a tree. Good design depends on the patterns and balances that exist everywhere within the picture.

The starting place is the shape of your page. Compositional sketches can begin as quite small notes in your sketchbook, testing out the possibilities of alternative shapes of rectangle. The page size of the paper you are working on need not always dictate the boundaries of your composition. Begin with a positive picture shape and compose within it. In this way the forces of the shape's geometry can be used. This sounds more complicated than it is.

Most of us have an instinctive sense of balance and arrangement and this is your best guide. The outer shape of your composition will generate energies leading into the picture. Some artists may do the opposite, beginning with the main subject and working outwards, finally deciding where to put the boundary edges of the picture. This often leads to weakening energies dispersing from the subject, and to what I might call a 'one-way picture', where your eyes go straight to the subject and stay there.

A good composition will keep your eyes moving, linking details in such a way that your eyes travel on, and the picture renews itself, able to reveal other levels of association and meaning.

Artists seldom take up the first ideas that come into their heads. Let first thoughts on composition grow and develop; play around with alternatives, gradually bringing your intentions into focus by re-arrangement and the elimination of all that is inessential. Use the potential energies and rhythms in the backgrounds – rocks, trees, water, shadows, areas of light and dark – these are the expressive elements that give life to your ideas.

The choice of where to use details or emphases depends on where these moments come within the composition. It would be unthinkable for an artist to

◀ ▲

Bruce Pearson
Composition studies in studio sketchbook, including Kestrels and Wallcreeper
various media

Bruce keeps a studio sketchbook in which he plans the possible layouts for his paintings. On the pages above the artist writes:

'It was the patterns of shadows, cast by two kestrels on a sheer rock face, which first caught my eye. In a way they were more interesting than the birds.

The kestrels moved effortlessly and with supreme aerial elegance, but the shadows were fragmented

and made more erratic by the indentations of the rock face – one moment rippling over the pitted rock, then vanishing into dark fissures; another moment briefly still, then as dark shards slipping away suddenly over a bluff.

After drawing the birds and shadows for a while, I worked on a sheet or two of thumbnail sketches, trying to reflect the sensations generated by what I had seen.'

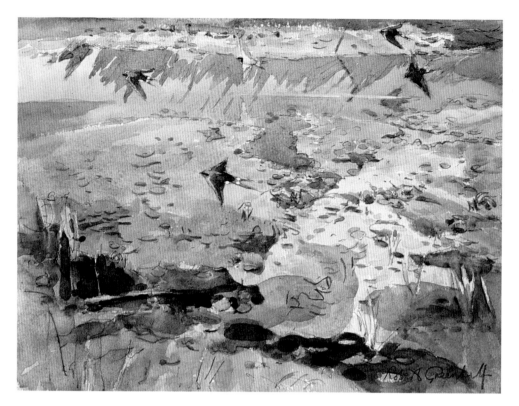

◄

Robert Greenhalf
Swallows over a marsh
watercolour

Colour is the main element in the composition of this picture. There are no strong shapes or lines, and the birds become part of the general flicker of movement leading into the painting. The colour harmonies vibrate towards you from the painting.

►

Robert Greenhalf
Great Tits
watercolour

The birds are placed naturally among the strong rhythmic lines of the branches as if they had just arrived that second and may go at any moment. They are about their own business, not posing.

complete a drawing of a bird, however accurate and ornithologically right, and then place it unaltered within a picture. A different placing of the same bird would call up different emphatic moments within it. These moments come from the initial placing and not the other way round. A stooping falcon, for instance, will not be more convincing in its speed for having all its tail feathers counted, but by how well your eyes are led forward through its body and across the 'charged' space before it. With flying birds in particular, it will increase a sense of movement to project the main rhythmic lines of the birds, and make some focal point ahead which will pull the birds towards it. In David Bennett's painting of two Stonechats flying, notice how the black throat of the male draws the eye strongly to the right against the softer fluttery rhythms of the heathland.

All the shapes you use in a picture are to a large extent pointers to other parts of the picture, and when this energy is picked up the eyes can jump across space easily. Composing the spaces of, say, a milling seabird colony can be more of a challenge than drawing the birds!

Colour and tone can also be used in a rhythmic way, as your eyes will move towards the brightest moment, say, of red, through the muted areas of similar colour, as they will towards the strongest contrasts of tone or even the sharpest edges – any accents that pull the eyes. Everything you put into a picture affects everything else in it. Increase the dark tones and the light ones shine more brilliantly; surround a muted yellow with cool greys and blues and it will

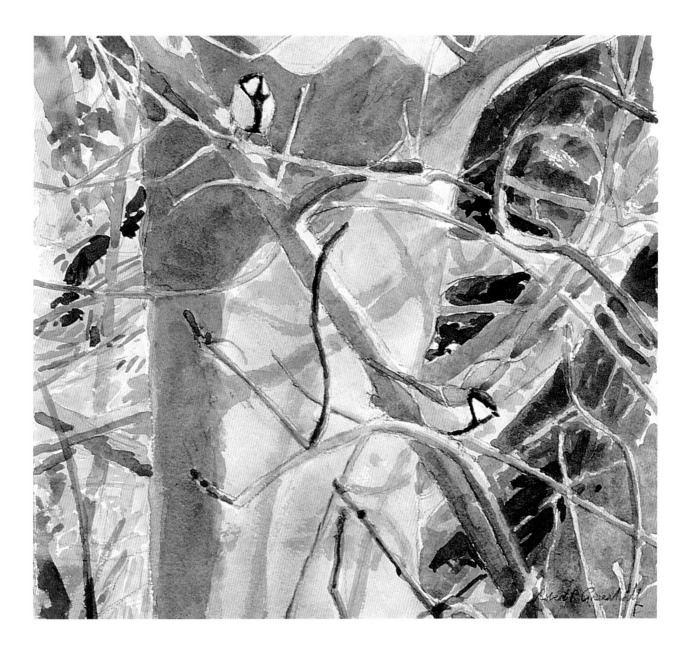

glow more than the brightest yellow next to reds and browns. One line will throw and catch another like a player in a ball game. All the elements in a picture have what is called 'pictorial weight'. Those that draw the eye towards them, whether a particular shape, a strong note of colour or tone, an emphasised line, a sharp edge, a focal point of detail, will probably outweigh larger quieter areas in the overall balance. It is all an exciting juggling game with your sensibilities and imagination.

To enjoy a picture our eyes need variety – tone and colour changes and relationships, variations of pace, the play of shapes and patterns. To engage the mind as well,

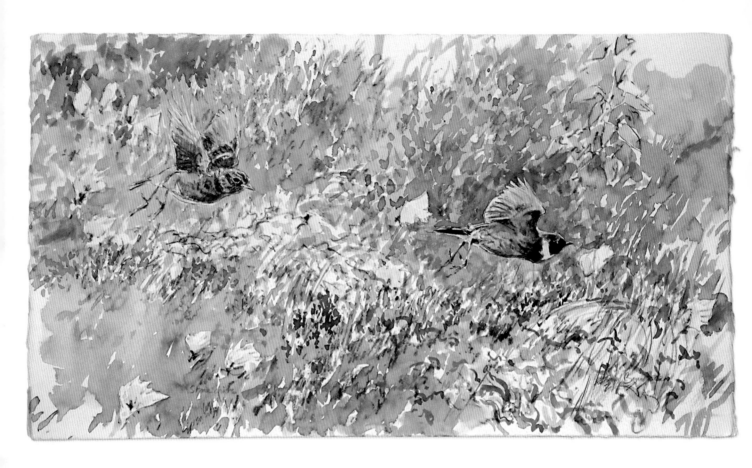

David Bennett
Stonechats
watercolour

A painting full of movement. Detail is not allowed to stop the eye, and you are drawn across the space in the direction of flight by the pictorial weight of the dark head of the male bird against the subtle counterpoint of background rhythms.

▶ ▶
David Bennett
Painting and sketch of a Bittern
watercolour

In contrast to the flow of the Stonechats, here David creates a mood of absolute stillness befitting the Bittern's frozen posture in the reeds, which adds a percussive beat.

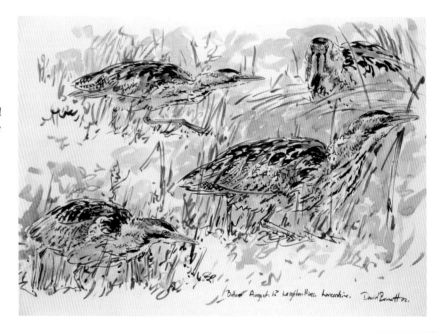

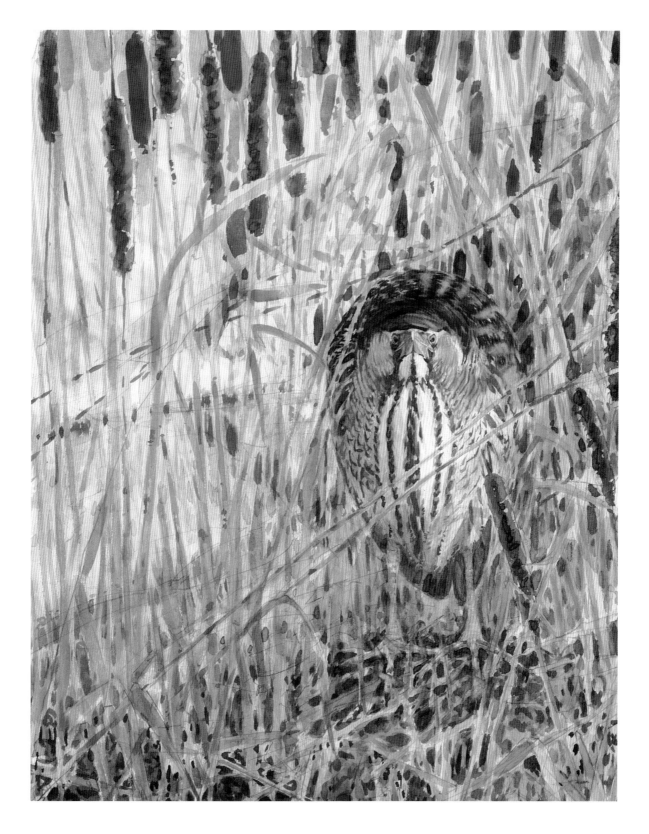

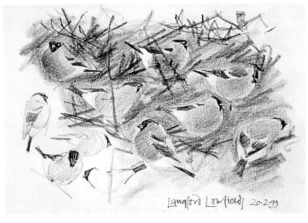

Langford Lowfields 20.2.99

◄ ▼

Mike Warren
Bullfinches
pencil, crayon, watercolour

Development of an idea from field sketch to a finished watercolour. As the complex background develops, the emphases and energies change until the overall balance is finally resolved.

► ▼

Barry Van Dusen
*Studies of parrotlets and junco
with swatches of colour*
watercolour

'I first started carrying scraps of
watercolour paper with my field
kit so I could test out colour mixes
and get the right water-to-
pigment ratio in my brush. I
usually clip the 'swatch' of paper
to the edge of my working sheet,
or tuck it under a rubber band
that holds my sheets secure in a
wind. I realised that the test paper
was also a good place to try out
potential combinations of 'colour
schemes', so the swatches often
became a sort of distilled abstrac-
tion of the finished work. They are
just tools, however, and I usually
discard them when I get home.'

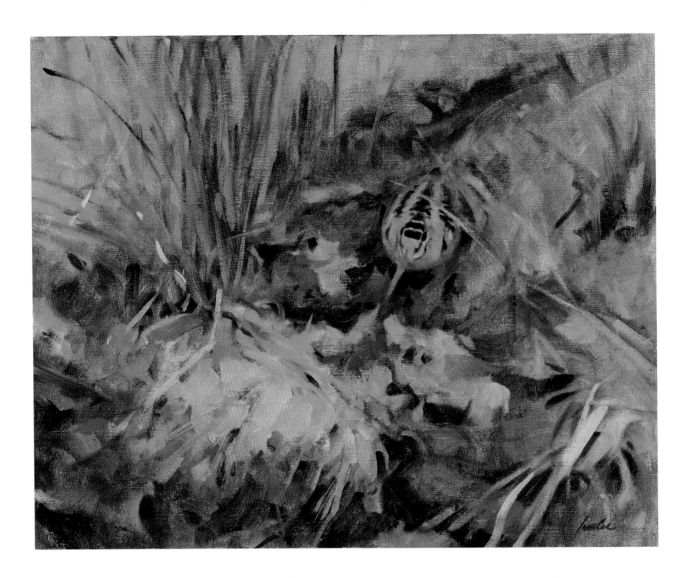

evidence of the artist's thoughts and feelings is essential. I hope these qualities are there in all the work chosen for this book, because even in a drawing of a single bird there is need for variety of emphasis, from strong definition to the delicacy of the merest suggestion. A flat, mechanical line will kill the form within any shape, as it will in music or the spoken word, while an expressive line will make it live.

It is really beyond the scope of a book entitled *Drawing Birds*, to go very far into

▲
James Coe
Spring Seep – American Woodcock
Oil on linen

'Wandering in my back-yard one early spring morning, I noticed this trickle of melt water and imagined a Woodcock poised along its edge–nestled into the matted tussocks of grasses.
My interest was caught by the contrast between the warm earthy hues of ochre *and sienna and the blue reflections of sky. I set up my easel and painted the scene on location, working quickly and directly returning to the painting several weeks later to 'clean up' the rough sketch of the Woodcock. The rest of the setting was left as I originally painted it.*

▶
(Léo) Paul Robert
Grimpereau des Jardins (Short-toed Treecreepers)
watercolour

A treecreeper family. A little known painting by this Swiss master. See also page 16.

the complexities of painting. I have tried to avoid a definition of drawing, taking it to mean the most direct means of expression in any medium – the way of 'drawing out' what is in the mind and eye of the artist.

Colour is a part of this too, a very personal language when used pictorially. It takes many years to see colour with an artist's eye. Indeed, though nearly all of us could detect a musical discord without any training, very few people could spot a colour discord or know when colours had a close relationship similar to a musical chord. We blandly accept that if the colours we see exist in nature they must be safe to put in a picture. I sometimes tell my shocked students that colour is too important to be left to nature – meaning that it is far more important that colours should be right to each other in the picture.

Colour is the most transient and changeable of all visual experiences, dependent entirely on the quality of light. The red of a Robin against the snow is not the same as the red breast barely visible beneath the holly bush, and has changed again when the bird hops out into full sunlight. Learn to see plumage as it is, not as your brain tells you it ought to be.

A painting may represent nature but it is a different reality, where colour takes on a new meaning in a fresh context. Local colours seen in isolation and matched one by one in your painting, will not guarantee truth. *Never use a colour that causes a disaster to the rest of your picture* even if you can see it out there.

One very simple tip for using colour in field sketching is to choose only a few colours to work with and not to copy literally the range of colour you see. You need at least one colour that is warm (for

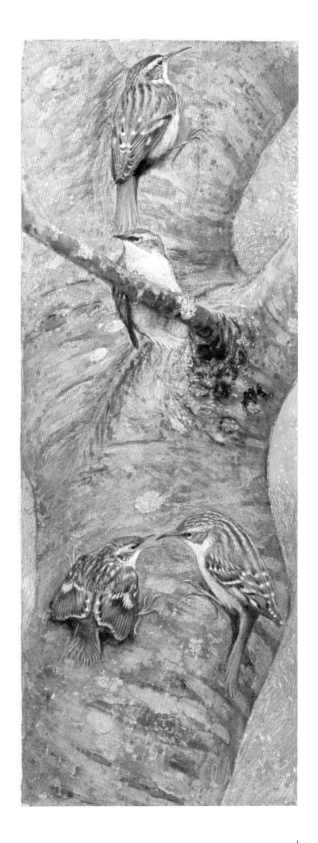

example, raw sienna or light red) and one that is cold (cobalt, Antwerp or Payne's grey). The basis of lively colours is the play between warm and cold colours. Look at what Darren Woodhead is able to achieve with light red and ultramarine blue, and how Barry Van Dusen sets the colour 'key' of his painting as a musician would do in sound.

Printmakers turn the limitations of two or three colours into striking designs.

I tend to use watercolour as the quick-est medium for field colour notes, using a sketchbook with good enough paper to take water without buckling. Other artists use coloured crayons most effectively. My most used colours are Payne's grey (a bluish black), ochre, light red, raw umber, cobalt green, cobalt blue, lemon yellow (the nickel titanate variety, which is very muted and opaque), with brighter colours held in reserve.

It is a good exercise to take, for instance, each yellow in your palette and see the

Greg Poole
Short-eared Owl hunting
skecthes, composition
studies and woodcut print

Cut directly into plywood
with gauges and then
offset onto two other
blocks for the brown and
orange printings.

'The owls appeared in
early autumn during a
huge vole population
explosion. Five birds
hunting over set-aside,
emerging just as it got
dark. The charcoal
drawings were made from
memory in near darkness
after watching.'

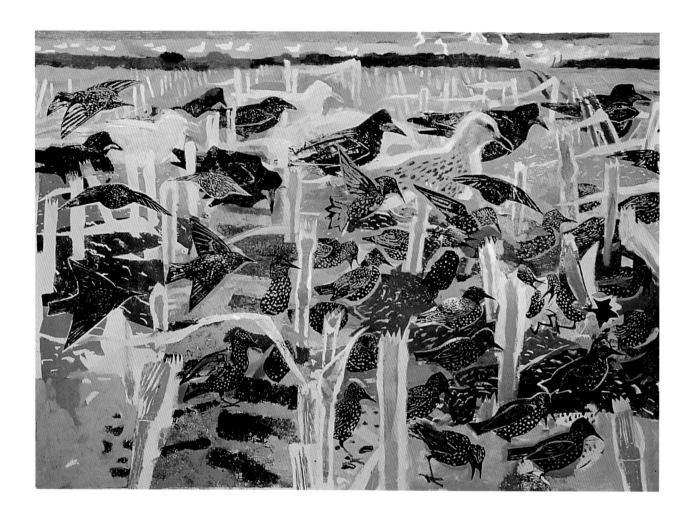

▲

Kim Atkinson
Maize stubble
Autumn
monoprint

Each print is a one-off. The prints begin with acrylic painted rather randomly onto the paper acting as an initial textural layer. The paper is then taped down and a base layer of ink added to Perspex, masked with paper and transferred with pressure of rollers or a wooden spoon. Then more ink is applied from pieces of card cut to shape, the ink often scratched into and some direct painting added. The inks used are non-sticking relief-printing inks plus oil paint mixed with extender base, or linseed oil in winter.

range of greens you can make mixing it with all the blues (and black) in turn, doing the same for browns, purples and oranges. The duller the colours the easier they are to handle, and brightness, as I suggested earlier, is induced rather than squeezed straight out of a tube. Begin with the largest areas, leaving the points of greatest brightness and strongest tones until last, although in your sketches, know where they are to come. Place all accents carefully early on. Unity in a painting is worth fighting for – it won't come without a struggle.

Finally, be true to your own observations

in the field, and in colour be true to your artistic instincts. Never devalue your field sketches by comparing them unfavourably with the finished work of others. Authentic records of moments seen have, I believe, more value than the most artful reconstruction because the experience behind them is genuine. In any finished work try to keep to the spirit of the sketches. This is by no means easy, and almost impossible if you try to 'freeze-dry' a sketch exactly. Use sketches as a guide, but redraw from memory stimulated by your field work, carefully composing the energies in your more considered painting before rushing into detail. If you lose the life of the bird in the process, tear it up and start again – and again.

Keep going in spite of early 'flops'. It may take half a lifetime to fly with the birds. The more you do, the better you will become, *especially* if you enlarge your observation to include all manner of other things in the scope of your drawing, such as people, still

▲

Madeline Goold
Gannets
glass, steel and shadows

A sculpture inspired by Gannets' beautiful greeting display – bill fencing and head bowing. The cast shadows are an integral part of the sculpture, echoing the forms. Made after watching and drawing Gannets on the Bass Rock.

▼

Kim Atkinson
Yellowhammers feeding on the hen's corn
monoprint

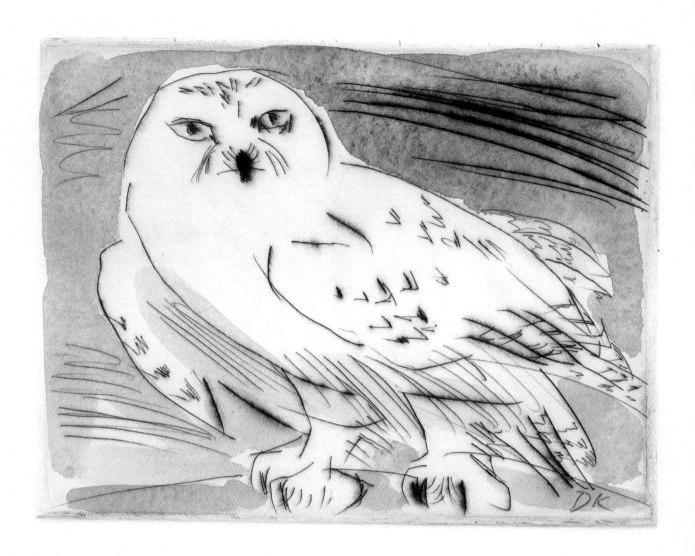

David Koster
Snowy Owl
drypoint etching with
added watercolour

*The strong black ink lines
seem to bring out the latent
threat of the owl about to
take off.*

*Snowy owls breed
successfully in zoos and are
great birds to draw. In the
wild they are rare winter
visitors to Britain. A pair
bred in Shetland in 1967.*

life, or landscape. Be adventurous, both in
the field and in the studio. There are new
understandings of bird behaviour and
ecology to be expressed today, and the
portrayal of birds is in great need of fresh
vision to match. Can painting that merely
repeats past wildlife-art conventions be
capable of expressing fresh ideas or giving a
lead? I doubt it. Those who buy wildlife art
also need to be far more adventurous and
discerning, rejecting second-hand clichés and
recognising the value of original experience.

With so much of our wildlife under
threat, the more we can cement emo-
tional links to nature in a deep, apprecia-
tive, but unsentimental way, the more it
will strengthen the public will for
conservation. Artists as individuals or
collectively (working with groups such as
the Artists for Nature Foundation in
Europe) have a lot of challenging work to
do in presenting the reality of nature as
one of the inspiring and urgent themes
of today.

▶ ▼

Robert Gillmor
Snooze and Preen. Avocets at rest
two-colour lino cut print
and sketch

*A fine example of the artist's
elegant rendering of the
bird's shape and plumage.
Based on sketches from life
and a life-long passion for
avocets. Thanks to the
conservation work of the
RSPB at Havergate and
Minsmere Reserves when
avocets re-appeared in
Britain in the mid 1940s,
there are now well estab-
lished breeding colonies in
southern England.*

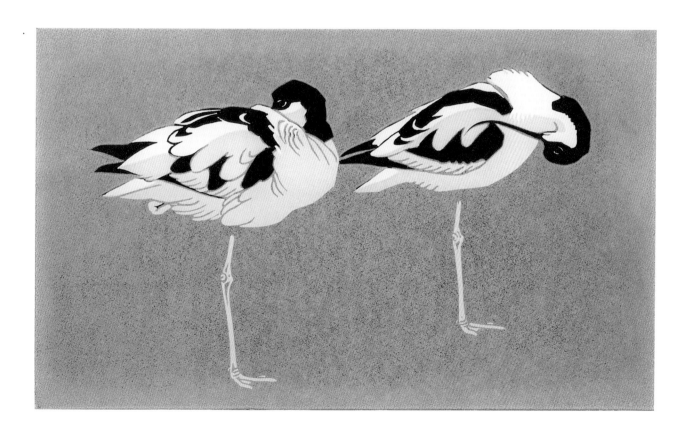

Artists' Biographies

Kim Atkinson, SWLA

Kim lives on the coast of north-west Wales, where fields, cliffs and her own garden provide subjects for paintings, drawings and printmaking. She is a graduate of the RCA and has taken part in several ANF projects, and with groups of artists in the New Forest and French Alps.

David Bennett, SWLA

Born 1969. Studied at Doncaster, and Leeds Art Colleges and Royal College of Art – MA in Natural History Illustration. Freelance artist since 1995. One-man exhibitions at The Wildlife Art Gallery, Lavenham. Joined ANF projects in Extremadura, Wexford and Alaska.

David Boys

Born Kent 1960. Studied illustration at Maidstone College of Art and Royal College of Art, graduating 1985. Freelance artist, teacher and designer, taking courses at London Zoo. Author of *Draw and Sketch Animals* (North Light Books, 2003).

Keith Brockie, SWLA

Born 1955. Studied at Duncan of Jordanstone College of Art, Dundee. Freelance artist since 1979. His *Wildife Sketchbook*, published in 1981, showed his exceptional talent as an artist and naturalist. It was followed by *One Man's Island*, *The Silvery Tay*, *Mountain Reflections* and *The Great Wood of Caledon* (with Hugh Miles) and recently *Dancing with Ospreys* and *Rural Portraits* with Polly Pullar. He took part in ANF projects in Holland, Poland, and Alaska, and has accompanied expeditions to Lapland and the Middle East.

John Busby, ARSA, RSW, SWLA

Born Yorkshire 1928. Drew animals from an early age. Studied at Leeds and Edinburgh Colleges of Art and taught drawing and painting at Edinburgh College of Art 1956–88. Founder member Society of Wildlife Artists. Exhibited widely in UK and abroad and work in several public and private collections, including HRH The Duke of Edinburgh. Took part in ANF projects in Holland, Poland, Spain, Portugal and India. Illustrated over 35 books and author of *Drawing Birds* (RSPB, 1986), *Birds in Mallorca, The Living Birds of Eric Ennion*, and *John Busby – Nature Drawings*. Lives in East Lothian.

Alexander Campbell, RSA, RSW

Born 1932. Studied and later taught for many years at Edinburgh College of Art. Animals and birds are occasional subjects in the range of this artist's work, always they show his affinity and feeling for their character. He exhibits widely in the UK and is represented in many Scottish collections.

Denis Clavreul, SWLA

Born 1955. Doctorate in Ecology from Rennes University. Self taught as an artist. Took part in ANF projects in Poland, Extremadura, and The Loire. He illustrated and wrote *Carnets naturalistes de la pointe de la Bretagne* and *La Corse* – one of the Carnet du Littoral series of artist's books.

James Coe

Born 1957. Studied biology at Harvard, and graduated with a Master's degree from Parson's School of Design, New York. Influenced by Fuertes, 'The father of us all here in the States', and by Don Eckelberry and Guy Tudor. He has published identification guides to both Western and Eastern North American birds, and birds of New Guinea. He is a member of the Society of Animal Artists and has exhibited at Leigh Yawkey Woodson Art Museum's 'Birds in Art', and many other venues. As well as birds, he paints on site oils of landscape. He lives above the Hudson River Valley, New York.

Katrina Cook, SWLA

Born 1965. Studied at Exeter College of Art then Royal College of Art. She works mostly in drypoint and aquatint, using pencil and watercolour for field work, and she has a keen interest in anatomy. She likes to work in wild inaccessible places. She is a member of and exhibits regularly at the SWLA.

Joseph Crawhall 1861–1913

Born in Northumberland. Already an impressive artist at the age of 14. Studied at King's College, London, and later in Paris at the studio of Aimé Morot. Closely associated with Glasgow artists E. A. Walton and James Guthrie and others of the 'Glasgow Boys'. Known to his friends as 'The Great Silence' because of his retiring disposition. He was a perfectionist in his art, destroying anything which did not meet his own exacting standard. He frequently visited North Africa to paint. He moved finally to Yorkshire. Many of his finest paintings are in the Burrell Collection in Glasgow.

Barry Van Dusen, SWLA

Born 1954. Studied Visual Design at Southeastern Massachusetts University. Freelance artist and illustrator since 1985. Took part in ANF projects in Extremadura, Wexford, India and Peru. Exhibits regularly at SWLA, London and 'Birds in Art', Leigh Yorkey Woodson Museum, Wisconsin.

Eric Ennion 1900–1981

Doctor of medicine, naturalist, artist and educator. Left medicine in 1945 to run Flatford Mill Field Centre, the first Field Studies Council Centre in Britain. Opened his own bird observatory and field centre on the Northumberland coast in 1950, moving to Wiltshire ten years later where he ran annual courses for bird artists. He wrote and illustrated many articles and books, broadcasted regularly on radio and exhibited paintings. With Robert Gillmor he set up the Society of Wildlife Artists (SWLA) whose first exhibition was held in London in 1964. His work sets the standard for most living bird artists in Britain.

Robert Gillmor, SWLA

Born in Reading in 1936, the grandson of A.W. Seaby (himself a renowned artist). Studied Fine Art at Reading University and taught at Leighton Park School before going freelance as an illustrator. *A Study of Blackbirds* by David Snow was the first of a long list of distinguished bird books with Gillmor illustrations. He has served on the councils of the BTO, BOU and RSPB, and with Eric Ennion set up the SWLA which he served as President for many years up to 1994.

Madeline Goold

After studying and practising law she achieved a BA in sculpture at Wolverhampton and an M.Phil. at Birmingham University. Since then has combined family life with printmaking and sculpture in stone, steel and glass. Shortlisted for the Millfield International sculpture prize, she won the Plowden and Thompson prize for glassmaking in 2000. In 2001, as the Gerald Finzi Centenary artist, her exhibition of sculpture and engravings, *How Like an Angel*, at Ludlow Festival, celebrated the Gannets on the Bass Rock. She also writes and speaks about art, gardens and natural history, inspired by North Worcestershire where she lives.

Robert Greenhalf, SWLA

Born 1950. Studied at Eastbourne and Maidstone Schools of Art. Freelance artist since then. He lives in East Sussex near to Rye Harbour Nature Reserve where he is involved in its management. His work is based on field observation and finds expression mostly in watercolours and print making. He has joined Artists For Nature projects in Europe, Alaska and India, and was Artist in Residence in the Parc des Ecrins in the French Alps. His book, *Towards the Sea*, was published by Pica Press in 1999.

Jennie Hale

After graduating from Loughborough College of Art, she set up her own Longham Pottery near Oakhampton in Devon. She has exhibited her Raku pottery sculptures in many galleries throughout the UK and she won a prize for her nature diary awarded by the BBC *Wildlife* magazine. She is setting up a 'Workshop Under The Sky', a nomadic arts and environment workshop, where groups will be encouraged to respond to all aspects of nature in a creative way. www.jenniehale.co.uk

Alan Johnston

Born 1959. Trained as a taxidermist at Glasgow Museum before studying at Dyfed College of Art. Worked as a graphic designer for Luxemburg State Museum of Natural History. Arranged an international exhibition of wildlife art in Luxembourg in 1989. He followed the migration of Black Storks from Luxembourg to Africa for *In Black Stork Country* (2000). His other books are *My Small Sketchbook*, *La Baie de St Michel*, and *Le Cap de la Hague*.

Lars Jonsson, SWLA

Born 1952. First exhibited in Stockholm Natural History Museum at age of 15. Self taught as an artist, inspired by Liljefors. Author and illustrator of five pioneering handbooks of *Birds of Europe*, published later as a single volume which sets the standard for all field guides. His paintings show him to be foremost among contemporary European bird artists; a status confirmed by his large one-man show, *Birds and Light*, in Stockholm in 2002. He joined

ANF projects in Extremadura, Alaska, India and Peru, and has travelled widely in the USA and the far north and east.

David Koster, SWLA

Began drawing birds at age of nine inspired by A.W. Seaby paintings in Kirkman and Jourdain's *British Birds*. Studied at the Slade School of Fine Art. Lecturer at Medway College of Design, Founder Member SWLA. David is primarily a printmaker and exhibits widely in Britain. He lives in Folkestone and has a cottage in Plockton on the west coast of Scotland.

Clare Walker Leslie

Professional artist, naturalist and teacher, living in Cambridge, Massachusetts. She has developed courses and workshops throughout the USA to encourage people to draw from nature, and has written several books on the subject. She took part in the ANF project to Extremadura in Spain, and has been part of scientific expeditions in other parts of the world.

Ian Lewington, SWLA

Born 1964. Freelance bird illustrator since 1985. No formal art training, but influenced by his brother Richard, illustrator of insect books, and Lars Jonsson and Raymond Harris-Ching. He is a keen field ornithologist and has painted detailed plates for *Birds of the World* and other books.

James McCallum

Born in Norfolk 1967, where early interest in birds and art developed. Studied at Carmarthen then at Royal College of Art (MA 1996). Works outdoors 'learning bird behaviour and to paint quickly and accurately', and spent several years as warden on nature reserves. Norfolk is still his base and chief inspiration, but he has followed

migration routes to Africa and Lapland, joining expeditions in Siberia and ANF project in the Pyrenees in 2002. His own books are *North Norfolk – wildlife through the seasons*, *Wild Goose Winter* (runner-up in British Bird Book Awards, 2002), and *Norfolk Summer*, 2003.

Larry McQueen

Born 1936. Began watching birds as a child in Pennsylvania. Studied ecology and conservation at Idaho State University and worked for Idaho Game Commission. After army draft in 1960s he studied Art at Oregon University and worked as a graphic artist before specialising in bird illustration and painting. He exhibits regularly in the Leigh Yorkey Woodson *Birds in Art* exhibitions, and has illustrated field guides to the birds of Peru and the Indian sub-continent. He lives in Eugene, Oregon.

Steve McQueen

Born 1964. Studied at Duncan of Jordanstone College of Art, Dundee, and has taught drawing there and at Glasgow School of Art since 1993. He won the *British Birds* Award for bird illustration in 2002. He works in various media and cites influences ranging from Joseph Beuys to Lars Jonsson and most recently James McCallum.

David Measures, SWLA

Born 1937. Studied at Mid-Warwickshire and Bournemouth Colleges of Art, and the Slade School of Fine Art. He taught painting and printmaking at Nottingham College of Art until 1992. He is an experienced field naturalist, interested in all forms of nature, particularly butterflies, which are the subject of his books, *Bright Wings of Summer* and *Butterfly Season*. In 1973 he featured in *David's Meadow*, one of the television series *Bellamy's Britain*. A

selection of his field sketchbooks was toured by the Arts Council in 1984. He took part in the ANG project in Extremadura in 1994, and he is a member of the SWLA.

Janet Melrose

Born 1964. Studied at Edinburgh College of Art, graduating in 1986. She exhibits widely in Scotland, and her paintings have a broad range of subjects, ranging from travels in Thailand, to birds on the Bass Rock.

Killian Mullarney

Born 1958. All the Mullarney children were encouraged to draw and paint by their parents. For Killian, drawing birds was a natural consequence of the time he spent watching them. He worked as a commercial artist before going freelance in 1985. His knowledge and artistry comes to the fore in the acclaimed *Collins Bird Guide* of 1999. He leads birdwatching tours to the Middle East and other countries and lives in Co. Wexford.

Bruce Pearson, PSWLA

Born 1950. Studied at Gt. Yarmouth and Leicester Colleges of Art. Worked for the RSPB film unit and British Antarctic Survey before going freelance. He has travelled widely in search of subjects that reflect his fascination with the rhythm and restlessness of the natural world where wildlife, landscapes and people interact. His illustrations include four titles in the Hamlyn Bird Behaviour series *Seabirds, Waders, Wildfowl* and *Birds of Prey*; and monographs on *The Hobby* and *The Barn Owl* for Arlequin Press. He featured in Television programmes called *Birdscape* and *Beyond Timbuktu*. Took part in ANF projects in Poland, Spain, Portugal, Alaska, and with other groups of artists in the French Alps and the New Forest.

He exhibits at the Wildlife Art Gallery in Lavenham and was President of SWLA from 1994 to 2003.

Greg Poole, SWLA

Born Bristol 1960. Took a degree in Zoology at Cardiff University, then worked in conservation in Avon and as a warden on Bardsey Island and at Long Point observatory in Canada. With growing interest in field drawing he took a basic design course at an art college and set up as a freelance artist/illustrator in 1990, specialising in printmaking. He was elected member of the Society of Wildlife Artists in 1991, winning the Natural World Award and Artists for Nature Award. Since then he has taken part in ANF projects in France, Alaska, India, Portugal, Pyrenees and Peru. His publications include; *La Riviera*, one of Gallimard's Carnet du Littoral series (1999).

Darren Rees, SWLA

With a degree in Mathematics from Southampton University, he taught that subject for a while before pursuing painting full time. He is self taught as an artist and has won awards from RSPB, and *Birdwatch* and *Natural World* magazines. His first solo book, *Bird Impressions*, was runner-up in the Natural History Book of the Year Award 1993. He lives in Stirlingshire, Scotland.

Carl R. Sams II

Wildlife photographer from White Lake, Michigan.

J. A. Shepherd 1867–1953

A brilliant illustrator and cartoonist. He drew regularly for *The Strand Magazine*, *The Illustrated London News* and *Punch*, and illustrated many books, notably *The Bodley Head Natural History*. My favourite is his own *A Frolic Round the Zoo* – adventures of Blinx and Bunda, a white cat and a monkey, visiting other animals at London Zoo, published by Bodley Head in 1926.

Chloe Talbot Kelly, SWLA

Born 1927, the daughter of Richard Talbot Kelly. She began studying birds in the British Museum of Natural History at the age of 17. She has lived and worked in Africa, Australia and New Zealand, illustrating handbooks of the birds of these countries. She is a founder member of the SWLA.

Richard B. Talbot Kelly, SWLA, 1896–1971

Born in Birkenhead. After a distinguished military career during and after World War I, he became Art Master at Rugby School, retiring in 1966. During World War II he was chief instructor at the War Office School of Camouflage, and became a design consultant for the Pavilion of Natural Sciences at the Festival of Britain in 1951. He was elected RI in 1926 and was a founder member of the SWLA. He is the author of *Birdlife and the Painter*, and *The Way of Birds*.

Charles Tunnicliffe, RA, SWLA, 1901–1979

Born in 1901 and grew up on his father's farm near Macclesfield, Cheshire. At 21 he won a scholarship to the Royal College of Art, specialising in etching and engraving. Henry Williamson's *Tarka the Otter* was the first of may books he illustrated with woodcuts, and the same author's *Peregrine Saga* fired his interest in birds. In 1947 he moved to Anglesey, and the landscapes and wildlife of his home inspired *Shorelands Summer Diary* and many other books and paintings. All his art shows the deep first-hand knowledge he aquired as an artist/naturalist. In 1954 he was elected Royal Academician and received the OBE in 1977. He died in Anglesey in 1979.

John Walters

Born 1964. He has been interested in all aspects of natural history from an early age. John studied art at Falmouth and then became graphic designer for the Dartmoor National Park Authority from 1991–99, He is now a freelance designer, illustrator and ecologist, and is the author of *Devon – wildlife through the seasons* (Arlequin Press, 2000) and co-author of *The Wildlife of Hayling Island* (2001). He lives in Buckfastleigh, Devon.

Mike Warren, SWLA

Born 1938. Professional artist, specialising in birds since 1972. All his work is based on field experience. He has exhibited in various countries, and illustrated many books including his own *Shorelines*, as well as postage and conservation stamps. He took part in ANF projects in Poland, Spain, Portugal, Ireland, & Peru. He lives near Newark.

Darren Woodhead, SWLA

Born 1971. Studied at Carmarthen and Royal College of Art. Married to artist Pascale Rentsch and lives by the Firth of Forth in Scotland. Works exclusively from life on all aspects of nature. Took part in ANF projects in Portugal, Pyrenees and Peru, and with other artists in the New Forest. Exhibits regularly at the SWLA.

Abbreviations used

ANF	Artists for Nature Foundation
ARSA	Associate of the Royal Scottish Academy
BTO	British Trust for Ornithology
BOU	British Ornithologists' Union
RCA	Royal College of Art
RSPB	The Royal Society for the Protection of Birds
RSW	Royal Scottish Society of Painters in Watercolour
SWLA	Society of Wildlife Artists

Bibliography

A selection of books of particular interest to bird artists. Compiled by Bob Walthew.

Artists for Nature Foundation projects

Schiermonnikoog: *Wind, Wad & Waterverf*, Benjamin & Partners, 1992.

Poland: *Portrait of a Living Marsh*, Robin D'Arcy Shillcock, Inmerc BV, 1993.

Extremadura: *Artists for Nature in Extremadura*, edited by Nicholas Hammond, The Wildlife Art Gallery, 1995.

Loire: *Pour une Loire Vivante – That the Loire may Live* (bilingual), Gallimard, 1996.

Alaska: *Artists for Nature in Alaska's Copper River Delta*, Riki Ott, The Wildlife Art Gallery, 1998.

India: *Tigers: Artists for Nature in India*, edited by Nicholas Hammond, The Wildlife Art Gallery, 2000.

Portugal: *Quadros de Vida – Living Paintings* (bilingual), Quinta do Lago, 2002.

Pyrenees: *Boscos Vells – Mature Forests* (bilingual), Lynx Editions, 2003.

Other books that feature the work of several artists

The Book of Birds, A. M. Lysaght, Phaidon, 1975.

American Wildlife Painting, Martina R. Norelli, Watson-Guptill, 1975 / Phaidon, 1976.

The Art of Natural History, S. Peter Dance, Country Life, 1978.

Nature Drawing: A Tool for Learning, Clare Walker Leslie, Prentice Hall, 1980.

Wildlife Artists at Work, Patricia Van Gelder, Watson-Guptill, 1982.

The Art of Field Sketching, Clare Walker Leslie, Prentice Hall, 1984.

Second Nature, edited by Richard Mabey, Jonathan Cape, 1984.

Wildlife Painting: Techniques of Modern Masters, Susan Rayfield, Watson-Guptill, 1985.

Twentieth Century Wildlife Artists, Nicholas Hammond, Christopher Helm, 1986.

Tomorrow is Too Late, compiled by Franklyn Perring and John Paige, Macmillan, 1990.

Nature in Art: A Celebration of 300 Years of Wildlife Paintings, David Trapnell, David & Charles, 1991.

Pintores de la Naturaleza, Robin D'Arcy Shillcock, Banco Central Hispano and SEO/Birdlife, 1997.

Modern Wildlife Painting, Nicholas Hammond, Pica Press, 1998.

Drawn to the Forest: The Society of Wildlife Artists in the New Forest (text by Robert Burton), The Wildlife Art Gallery, 2000.

More Wildlife Painting: Techniques of Modern Masters, Susan Rayfield, Watson-Guptill, 2000.

Birds in Art, catalogues of the Leigh Yawkey Woodson Art Museum, annual exhibitions since 1976.

Books by, or featuring the work of, individual artists

JOHN JAMES AUDUBON

The Original Water-colour Paintings by John James Audubon for The Birds of America, Michael Joseph, 1966.

John James Audubon: The Watercolours for The Birds of America, A. Blaugrund and T. E. Stebbins, Random House, 1993.

WINIFRED AUSTEN

Field River and Hill, Eric Parker, Philip Allan, 1927.

Marsh and Mudflat, Kenneth Dawson, Country Life, 1931.

Birds Ashore and A-foreshore, Patrick R. Chalmers, Collins, 1935.

ROBERT BATEMAN

The Art of Robert Bateman, Ramsay Derry, Viking/Madison Press, 1981.

The World of Robert Bateman, Ramsay Derry, Viking/Madison Press, 1985.

Robert Bateman: An Artist in Nature, Rick Archbold, Madison Press/Viking, 1990.

Robert Bateman: Natural Worlds (text by Rick Archbold), Swan Hill, 1996.

Robert Bateman: Birds (text by Kathryn Dean), Airlife Publishing, 2002.

JEMIMA BLACKBURN
Blackburn's Birds, edited by Bob Fairley, Canongate Press, 1992.

DAVID BOYS
Draw and Sketch Animals North Light Books, 2003.

CARL BRENDERS
Wildlife: The Nature Paintings of Carl Brenders, Abrams, 1994.

KEITH BROCKIE
Keith Brockie's Wildlife Sketchbook, Dent, 1982.

One Man's Island: paintings and sketches from the Isle of May, Dent, 1984.

The Silvery Tay: Paintings and Sketches from a Scottish River, Dent, 1988.

Mountain Reflections, Mainstream Publishing, 1993.

Drawn from Nature, Arlequin Press, 1995.

Cuaderno de Campo de la Naturaleza Española (with Miguel Delibes de Castro), Madrid, 1995.

Rural Portraits: Scottish Native Farm Animals, Characters and Landscapes by Polly Pullar, Langford Press, 2003.

GUNNAR BRUSEWITZ
Wings and Seasons, Wahlström & Widstrand/Croom Helm, 1980.

JOHN BUSBY
Birds in Mallorca, Christopher Helm, 1988.

Nature Drawings, Arlequin Press, 1993.

DAVID CEMMICK
Black Robin Country: the Chatham Islands and its wildlife (with Dick Veitch), Hodder & Stoughton, 1985.

Kakapo Country (with Dick Veitch), Hodder & Stoughton, 1987.

JEAN CHEVALLIER
Promenades Naturalistes en France, Nathan, 1992.

Le marais d'Orx (Collection Les carnets du littoral), Gallimard, 1996.

DENIS CLAVREUL
A la pointe de la Bretagne (with Yvon Guermeur), Nathan, 1995.

La Corse (Collection Les carnets du littoral), Gallimard, 1996.

Tanzania Notebook (with Guillemette de Grissac and Philippe de Grissac), Tanganyika Wildlife Safaris, 1996.

Dreaming of Africa, Rizzoli International, 2001.

JOSEPH CRAWHALL
Joseph Crawhall, Adrian Bury, Charles Skilton, 1958.

Joseph Crawhall: one of the Glasgow Boys, Vivien Hamilton, John Murray, 1990.

ERIC ENNION
Adventurers Fen, Methuen, 1942.

The British Bird, OUP, 1943.

The Story of Migration, Harrap, 1947.

The Lapwing, Field Study Books No.1, Methuen, 1949.

Bird Study in a Garden, Puffin Picture Book No.106, 1958.

The House on the Shore, Routledge & Kegan Paul, 1960.

Tracks (with Niko Tinbergen), OUP, 1967.

The Living Birds of Eric Ennion, John Busby, Gollancz, 1982.

Birds and Seasons, edited by Bob Walthew, Arlequin Press, 1994.

A Life of Birds, edited by Bob Walthew, introduction by Robert Gillmor, The Wildlife Art Gallery, 2003.

JON FJELDSÅ
Guide to the Young of European Precocial Birds, Skarv, 1977.

LOUIS AGASSIZ FUERTES
Louis Agassiz Fuertes and the Singular Beauty of Birds, F. G. Marcham, Harper & Row, 1971.

A Celebration of Birds: The Life and Art of Louis Agassiz Fuertes, R. M. Peck, Collins, 1983.

To a young bird artist: Letters from Luis Agassiz Fuertes to George Miksch Sutton, Stackpole Books, 1979.

ROBERT GILLMOR
Many books illustrated including:

The Wind Birds, Peter Matthiessen, The Viking Press, 1973.

The Herons of the World, James Hancock and Hugh Elliott, London Editions, 1978.

John Clare's Birds, edited by Eric Robinson and Richard Fitter, OUP, 1982.

ROBERT GREENHALF
Towards the Sea, Pica Press, 1999.

ROBERT HAINARD
Images du Jura sauvage, Tribune Editions, 1987.

Le monde sauvage de Robert Hainard, Duculot, 1988.

Nuits d'hiver au bord du Rhône, Tribune Editions, 1988.

Quand le Rhône coulait libre, Tribune Editions, 1989.

Croquis d'Afrique, Editions Hesse / Tribune Editions, 1989.

Le monde plein, Editions Melchior, 1991.

RAY HARRIS-CHING
Studies and Sketches of a Bird Painter, Lansdowne Editions, 1981.

Wild Portraits, Airlife, 1988.

Voice from the Wilderness, Swan Hill, 1994.

ALAN JOHNSTON

La baie du Mont St Michel (Collection Les carnets du littoral), Gallimard, 1996.

In Black Stork Country: Nature Sketchbook, Luxembourg, 2000.

LARS JONSSON

Penguin Nature Guides, 4 vols, Penguin Books, 1978–79.

Birds of the Mediterranean and Alps, Croom Helm, 1982.

Bird Island: pictures from a shoal of sand, Croom Helm, 1984.

En dag i maj, Atlantis, 1990.

Birds of Europe, Christopher Helm, 1992.

Lommar (with Toralf Tysse), Sveriges Ornitologiska Förening, 1992.

The Nature of Massachusetts, Leahy, Mitchell and Conuel, Perseus, 1996.

Dagrar, Wahlström & Widstrand, 2000.

Birds and Light, Christopher Helm, 2002.

EDWARD LEAR

Edward Lear's Birds, Susan Hyman, Weidenfeld & Nicholson, 1980.

BRUNO LILJEFORS

Bruno Liljefors: An Appreciation, Dr K. E. Russow, C E Fritze, 1929.

Det vildas rike, Albert Bonniers Förlag, 1941.

Bruno Liljefors by Allan Ellenius (in Swedish), Carmina, 1981.

Bruno Liljefors: The Peerless Eye by Martha Hill, Allen Publishing, 1987.

GEORGE LODGE

Memoirs of an Artist Naturalist, Gurney & Jackson, 1946.

George Lodge: Artist Naturalist, edited by John Savory, Croom Helm, 1986.

JAMES MCCALLUM

North Norfolk: wildlife through the seasons, Arlequin Press, 1999.

Wild Goose Winter: observations of geese in North Norfolk, Silver Brant, 2001.

Norfolk Summer, Silver Brant, 2003

DAVID MEASURES

Bright Wings of Summer (butterflies), Cassell, 1976.

Butterfly Season 1984, Arlequin Press, 1996.

KILLIAN MULLARNEY AND DAN ZETTERSTRÖM

Collins Bird Guide (with Lars Svensson and Peter Grant), large format edition, HarperCollins, 2000.

PETER PARTINGTON

Learn to Draw Wildlife, HarperCollins, 1998.

Learn to Draw Birds, HarperCollins, 1998.

BRUCE PEARSON

The Countryside in Winter, Brian Jackman, Hutchinson, 1985.

Birdscape (with Robert Burton), HarperCollins, 1991.

An Artist on Migration, HarperCollins, 1991.

Hamlyn Bird Behaviour Guides: Birds of Prey, Seabirds, Wildfowl, Waders (illustrator), Hamlyn, 1993–94.

La Camargue (Collection Les carnets du littoral), Gallimard, 1997.

In a New Light, The Wildlife Art Gallery, 2003.

GREG POOLE

La Riviera (Collection Les carnets du littoral), Gallimard, 1999.

ROGER REBOUSSIN

Les Oiseaux de France, Pierre Jeanson, 1999.

DARREN REES

Bird Impressions: A Personal View of Birds, Swan Hill, 1993.

Portrait of Wildlife on a Hill Farm by Anne McBride and Tony Pearce, Whittet Books, 1995.

DAVID REID HENRY

Highlight the Wild: the art of the Reid Henrys, Bruce Henry, Palaquin Publishing, 1986.

ANDREA RICH

The Woodcuts of Andrea Rich, Many Names Press, 1997.

RICHARD RICHARDSON

Guardian Spirit of the East Bank: a celebration of the life of R. A. Richardson by Moss Taylor, Wren Publishing, 2002.

LÉO-PAUL ROBERT

Unsere Vögel (with Eugène Rambert), Avanti Club, 1951.

Les Passereaux, Paul Géroudet, 3 vols, Delachaux & Niestlé, 1953–54.

CHRIS ROSE

Grebes of the World, Malcolm Ogilvie, Bruce Coleman, 2003.

PETER SCOTT

Morning Flight, Country Life, 1935.

Wild Chorus, Country Life, 1938.

Observations of Wildlife, Phaidon, 1980.

Travel Diaries of a Naturalist vols 1–3, Collins, 1983–87.

Sir Peter Scott at 80: A Retrospective, Alan Sutton, 1989.

The Art of Peter Scott: Images from a Lifetime selected by Philippa Scott, Sinclair-Stevenson, 1992.

ALLEN W. SEABY

The British Bird Book, edited by F. B. Kirkman, T C & E C Jack, 1910–13.

The Birds of the Air, A & C Black, 1931.

British Birds by Kirkman & Jourdain (reissue of the plates from *The British Bird Book*), T C & E C Jack, 1932.

COLIN SEE-PAYNTON
The Incisive Eye: Wood Engravings 1980–
1996, Ashgate, 1996.

KEITH SHACKLETON
Tidelines, Lutterworth Press, 1951.

Birds of the Atlantic Ocean (text by Ted
Stokes), Country Life, 1968.

Wildlife and Wilderness: an artist's world,
Clive Holloway Books, 1986.

*Keith Shackleton: an autobiography in
paintings*, Swan Hill, 1998.

J. A. SHEPHERD
The Arcadian Calendar, E. D. Cuming,
George Newnes, 1903.

The Bodley Head Natural History Vols 1
& 2, E. D. Cuming, John Lane/The
Bodley Head, 1913–14.

A Frolic Round the Zoo, The Bodley
Head, 1926.

Idlings in Arcadia, E. D. Cuming, John
Murray, 1934.

RAYMOND SHEPPARD
How to Draw Birds, Studio, 1940.

Drawing at the Zoo, Studio, 1949.

More Birds to Draw, Studio, 1956.

ROBIN D'ARCY SHILLCOCK
La presqu'île de Guérande (Collection Les
carnets du littoral), Gallimard, 1998.

FRANK SOUTHGATE
Wildfowl and Waders, Country Life, 1928.

R. B. TALBOT KELLY
The Way of Birds, Collins, 1937.

Birds of the Sea, R. M. Lockley, King
Penguin, 1945.

Paper Birds (to cut out and make into
models), Puffin Picture Book No.52.

Mountain and Moorland Birds, Puffin
Picture Book No.65.

Bird Life and the Painter, Studio, 1955.

A Bird Overhead, Clive Simson,
Witherby, 1966.

R. B. Talbot Kelly RI SWLA 1896–1971,
exhibition catalogue, The Wildlife Art
Gallery, 1992.

ARCHIBALD THORBURN
British Birds, 4 vols, Longmans, 1914–16.

A Naturalist's Sketchbook, Longmans,
1919.

*Game Birds and Wildfowl of Great
Britain and Ireland*, Longmans, 1923.

British Birds, new edition, 4 vols,
Longmans, 1925–26.

*Thorburn's Landscape: The Major
Natural History Paintings* by John
Southern, Elm Tree Books, 1981.

Thorburn's Birds and Mammals, John
Southern, David & Charles, 1986.

CHARLES F. TUNNICLIFFE
Bird Portraiture, Studio, 1945.

Mereside Chronicle, Country Life, 1948.

Shorelands Summer Diary, Collins, 1952.

A Sketchbook of Birds, introduction by
Ian Niall, Gollancz, 1979.

Portrait of a Country Artist by Ian Niall,
Gollancz, 1980.

Sketches of Bird Life, edited by Robert
Gillmor, Gollancz, 1981.

Tunnicliffe's Countryside by Ian Niall,
Clive Holloway, 1983.

Tunnicliffe's Birds (measured drawings of
dead birds), edited by Noel Cusa,
Gollancz, 1984.

Tunnicliffe's Birdlife, Noel Cusa, Clive
Holloway, 1985.

Charles F. Tunnicliffe RA: *The
Composition Drawings*, catalogue edited
by Robert Gillmor, Bunny Bird Fine Art,
1986.

Shorelands Winter Diary, introduction
by Robert Gillmor, Robinson
Publishing, 1992.

The Peregrine Sketchbook, edited by
Robert Gillmor, Excellent Press, 1996.

JUAN M VARELA
*Les Terres de Baliar: Apunts de natura i de
paisage* (text by Joan Mayol), Sa Nostra,
1998.

JOHN WALTERS
Devon Wildlife Through the Seasons,
Arlequin Press, 2000.

MICHAEL WARREN
Shorelines, Hodder & Stoughton, 1984.

Field Sketches, Arlequin Press, 1998.

Langford Lowfields 1989–99, Arlequin
Press, 1999.

Le Lac du Bourget (Collection Les carnets
du littoral), Gallimard, 2001.

DONALD WATSON
The Oxford Book of Birds (text by Bruce
Campbell), OUP 1964.

Birds of Moor and Mountain, Scottish
Academic Press, 1972.

The Hen Harrier, Poyser, 1977.

A Bird Artist in Scotland, Witherby, 1988.

One Pair of Eyes, Arlequin Press, 1994.

MAURICE WILSON
Drawing Animals, Studio, 1964.

Drawing Birds, Studio, 1965.

JOSEPH WOLFE
Animal Painter, Karl Schulze-Hagen and
Armin Geus, Basilicken-Presse, 2000.

ANDREW WYETH
The Two Worlds of Andrew Wyeth,
Thomas Hoving (people and places; not
birds), Houghton Mifflin, 1978.